Beginner's Guide
to Digital Photo Art

Beginner's Guide
to Digital Photo Art

Theresa Airey

LARK BOOKS

A Division of Sterling Publishing Co., Inc.
New York / London

Editor: Haley Pritchard
Art Director: Tom Metcalf
Cover Designer: Thom Gaines
Assistant Art Director: Lance Wille
Editorial Assistance: Delores Gosnell and Dawn Dillingham

Library of Congress Cataloging-in-Publication Data

Airey, Theresa.
 Beginner's guide to digital photo art / Theresa Airey.— 1st ed.
 p. cm.
 Includes index.
 ISBN 1-57990-775-X (pbk.)
 1. Photography—Digital techniques. 2. Photography in art. I. Title.
TR267.A347 2006
776—dc22

 2006004396

10 9 8 7 6 5 4 3 2

Published by Lark Books, A Division of
Sterling Publishing Co., Inc.
387 Park Avenue South, New York, N.Y. 10016

© 2007, Theresa Airey
Photography © 2007, Theresa Airey unless otherwise specified

Distributed in Canada by Sterling Publishing,
c/o Canadian Manda Group, 165 Dufferin Street
Toronto, Ontario, Canada M6K 3H6

Distributed in the United Kingdom by GMC Distribution Services,
Castle Place, 166 High Street, Lewes, East Sussex, England BN7 1XU

Distributed in Australia by Capricorn Link (Australia) Pty Ltd.,
P.O. Box 704, Windsor, NSW 2756 Australia

If you have questions or comments about this book, please contact:
Lark Books
67 Broadway
Asheville, NC 28801
(828) 253-0467

Manufactured in China

ISBN 13: 978-1-57990-775-4
ISBN 10: 1-57990-775-X

For information about custom editions, special sales, premium and corporate purchases, please contact Sterling Special Sales
Department at 800-805-5489 or specialsales@sterlingpub.com.

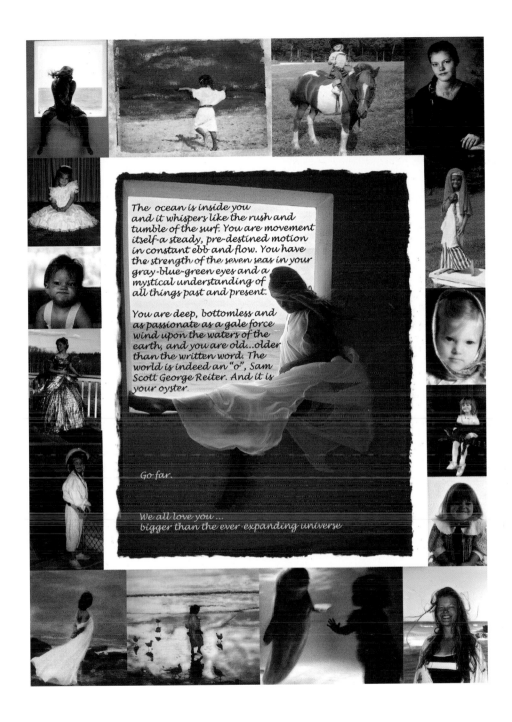

The ocean is inside you and it whispers like the rush and tumble of the surf. You are movement itself—a steady, pre-destined motion in constant ebb and flow. You have the strength of the seven seas in your gray-blue-green eyes and a mystical understanding of all things past and present.

You are deep, bottomless and as passionate as a gale force wind upon the waters of the earth, and you are old...older than the written word. The world is indeed an "o", Sam Scott George Reiter. And it is your oyster.

Go far.

We all love you ...
bigger than the ever-expanding universe

I would like to dedicate this book to my family. I am thankful for your support in my career and all my endeavors, and especially for your love.

"Love you all bigger than the universe."

contents

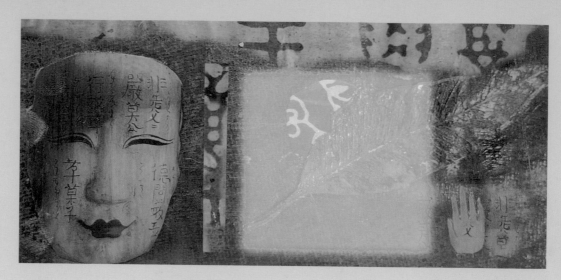

Introduction

If you own a digital camera and wish to do more than just make "everyday" prints, this is the book for you. You will learn how to take that snapshot and turn it into art—a collage, a sepia-toned sketch, a lovely print to hang on the wall, personalized cards for special events, and much more. The projects included here can be used for creative personalized gifts, or simply for your own enjoyment and artistic growth. This is a fun "jump-start-your-imagination" book, written to inspire anyone who wishes to enter the wonderful and creative world of digital photography.

Please note that in the project examples and instructions, I will most often refer to the Photoshop Elements and Photoshop CS software programs and their associated controls and commands. It is not necessary, however, to have either of these particular softwares in order to create the projects herein. Several other image-processing programs include similar commands and features. Just be aware that your program's controls may not have the same names and menus as those noted in these pages, even though they can create the same effects.

Since software is constantly being updated, you may also find that some of the commands and controls detailed here are not located in exactly the same place in the newer software versions. If this happens, don't panic! Just look up the command or control in question in your new software guidebook, or go to the software's Help menu. These are two very easy ways to help you navigate your particular software program and find the information you need.

That said, let's make some digital art!

Theresa Airey

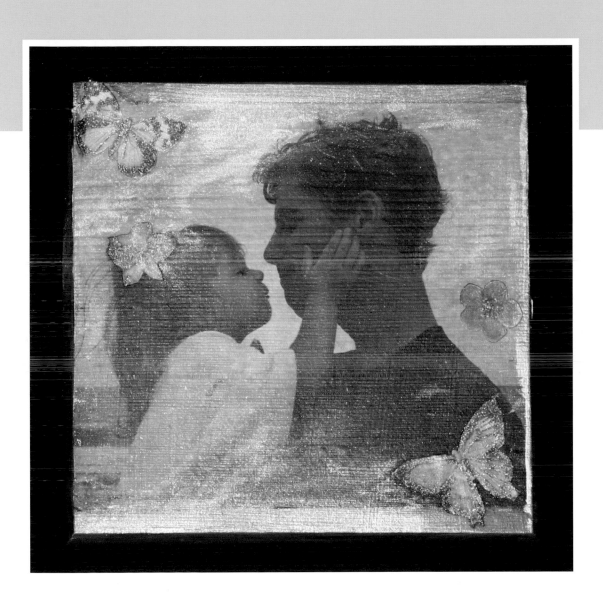

Chapter One: Digital Scrapbooking

Scrapbooking is a lot of fun, but the materials can be very expensive. By using your computer to make scrapbook pages, you can save time and money while creating a uniquely personalized project. Simply purchase a few basic scrapbook materials, then scan them to create digital files on your computer. This way, you can use the materials over and over again. Remember, it is easy to change the color, size, and look of whatever you scan so that it blends easily into your composition. You can even print out what you've scanned to use in "hands on" projects. The big plus is that you only have to purchase basic materials once. Take the expense out of scrapbooking and increase your productivity and creativity!

Hint: You can take a digital picture of items or materials if you don't have a scanner. Just make sure you have even lighting and watch out for shadow areas.

Easy Backgrounds

Wallpaper is a great material to use for creating scrapbook pages. Go to your local wallpaper store and borrow several pattern books. Make digital files of the patterns you like and keep them to use as backgrounds. Again, you can change color, size, and more using image-processing software so don't think that you are stuck with just one version of the design.

I also frequently photograph crumbling walls, peeling paint, reflections in water, or colorful signs and keep them in a "backgrounds" folder on my computer. If you see a lovely garden, take some close up shots of a cluster of flowers or an interesting leaf, then take a wide-angle shot. All of these come in handy when looking for the perfect background for your image or your scrapbook page layout. Give it a try! Take that lovely garden scene, for example, and use your image-processing program to lighten the overall picture so that it is very faint. To do this in Photoshop Elements:

1. Go to Enhance >Adjust Color > Adjust Hue/Saturation.

2. Use the Lightness slider to lighten the background, then drag images on top of the scene in layers and compose your design.

To do this in Photoshop CS:

1. Go to Image > Adjustments > Hue/Saturation.

2. Use the Lightness slider to lighten the background, then drag images on top of the scene in layers and compose your design.

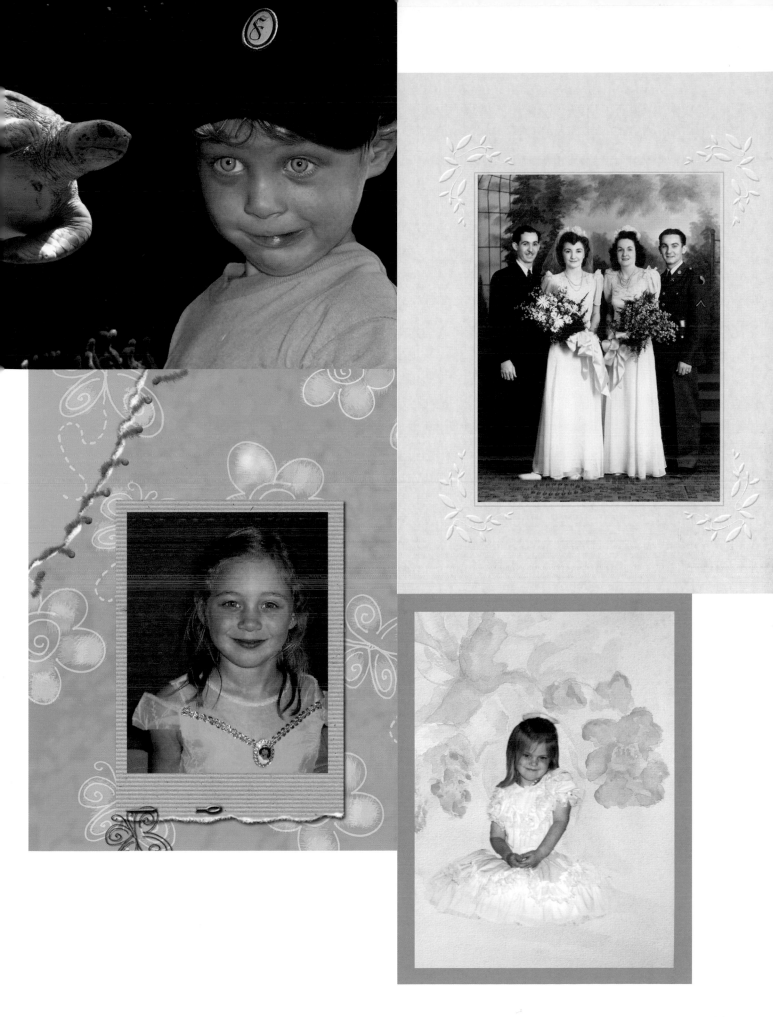

Use the Internet

Many people do not realize the wealth of free information that is available through the Internet. Use your favorite Internet search engine to look up specific art materials, manufacturers, art supply stores, or an artistic process you'd like to learn more about and you will soon see what I mean. (Refer to page 16 for information about how to download project ideas and elements from the Epson website.) Have fun putting this excellent resource to work.

Experiment with Layering

Layering images on top of one another and blending them together using image-processing software often results in unique and interesting effects that will add intrigue and excitement to your digital scrapbook pages. To access the Layers palette in Photoshop Elements and Photoshop CS, click on the Window tab, scroll down to Layers, and release. The Layer dialog box will open. When you have an image open onscreen and you drag another image on top of it, it will appear in the Layers palette as Layer 1. The original image will be labeled as Background.

Before I close a layered file, I flatten the layers. To do this, go to the Layers palette and click on the arrow across from the word Layers, then scroll down to Flatten Image. This will flatten all the layers into one single layer. However, once this is done and you close the file, you will no longer be able to access the image elements as separate layers. If you wish to continue to work on your image later and preserve the separate layers, you will need to save the layered file without flattening it. In some cases, I will do both; I save my layered file first, adding a capital L to indicate that it is a layered file (Samantha_L.tif, for example). You can either save the flattened image with the letter F (Samantha_F.tif), or with no designation (Samantha.tif), as I do.

Hint: When you open the Layers palette for the first time, click on the arrow across from the word Layers in the palette, then select Dock Palette to Palette Well. This way if you close the Layers palette, a Layers tab will be placed in the palette well (at the top right side of menu bar that runs along the top of the screen). Next time you want to access the Layers palette, just click on this tab and it will appear

The following are a few tips to keep in mind when experimenting with layering images:

Make sure that the images you wish to layer are of the same resolution.

To check this, go to Image > Image Size in Photoshop CS, or Image > Resize > Image Size in Photoshop Elements. Be sure that the ppi—or pixels per inch—listed for each of your images is the same.

Note: If the ppi for each image is not the same, the images may not line up properly—i.e., the registration will be out of sync—and/or the size of the print being moved over as a new layer will be too large or too small in proportion to the background image.

In photoshop CS, make sure that the Resample box that appears inside the Image Size dialog box is checked. Then, adjust the resolution to the desired ppi for all images in the layering project.

You cannot arbitrarily increase the ppi of a low-resolution image to a higher ppi. In most cases, you will have to match the resolution of other images in the layering project to the lowest ppi among them. However, one of the nice things about Photoshop CS is that it has a built in resampling tool that does a great job of adding pixels, within reason. If you need to add a lot of pixels, say around 100 ppi, to match up with higher-resolution images in your project set, simply check the Resample Image box in Photoshop CS and use Bicubic Smoother. Do this in several increments by adding 30 pixels at a time until you reach your goal. (If you are lowering ppi resolution, check the Resample Image box and use Bicubic Sharpener.)

In Photoshop Elements, you are limited to the Resample box without the smoothening and sharpening options available in Photoshop CS. You will find that the image will get pixelated (blocky and unnatural-looking) quickly if you try to add too much to the ppi count. In such cases, you will need to lower the resolution of the higher-quality image to match the lower-quality image's ppi count.

Note: If you are not certain about whether or not you have interpolated up more than will look acceptable in your final image (i.e., added too many pixels to the ppi count), make a test print of the image in order to check for quality and clarity. Remember, you cannot see how clearly (or not) your image will print simply by viewing it on the monitor; even a very low-resolution image will likely look sharp onscreen.

If you want two images to line up exactly, hold the Shift key down while you are dragging one image on top of the other.

In order to do this, of course, the images must be the same resolution and size or they will not register (i.e., line up) correctly. (I like to use this trick when I duplicate the original photo, change it to a black-and-white image or a sketch, and then drag the duplicated image over the original to create interesting effects.)

The blending modes found in the Layers palette allow you to blend two images together to create unique results.

The blending mode drop down menu will display Normal by default. Click on the drop down menu to access the other available blending modes. I usually start with the blending mode called Darken. Depending on the tonality of the prints being blended, different blending modes will work better than others for your specific project. You will be delighted at the results!

Creating a Layer Mask

Layer masks are a great way of altering your image without directly affecting your original file. You can play all you want, trying out different effects without applying them to the image, and your original image remains untouched. Think of a layer mask as a clear piece of acetate over your image. You can see the original image, but you are working on top of the acetate, which protects the image from actually being altered.

When working with a layer mask, you can alter your image by using various tools, such as the Paint Brush or Eraser tools, to apply special effects to the layer without actually affecting the original image. The original remains untouched until you flatten the layers, thus applying the changes that you have made on the mask to your file and making those changes permanent.

However, if you wish, you can also save your work as a layered file, which allows you to go back and rework the image or make further corrections. Keep in mind, though, that a layered file will take up a lot more room on your computer than a flattened file, and you may not be able to work with the layered file in other applications until you have flattened it.

To create a layer mask in Photoshop CS, simply highlight the layer you wish to use a mask on by clicking on it. Then go to the Layers palette and click on the icon of a rectangle with a circle in the middle. (If you hold your cursor near the icon without clicking on it, the words "Add layer mask" will appear.) When you click on the icon, a mask will appear automatically on the layer as an empty box along side of the image layer.

After working on the mask, if you do not like what you have done, you can simply click on the mask icon (the blank box that appeared next to the selected layer in the Layers palette) and drag it to the trashcan (located on the bottom right corner of the Layers palette). The image will not be thrown away when you do this, just the mask.

If you aren't sure if you like the work you have done, do not flatten the image before closing it. Just save it with the letter L at the end of the file name. When you open that file again later to reexamine your work, the mask and the various layers will still be separated, and you can alter or change them to your liking. You can also open up both the original file and the altered one to compare the two and see what's working and what's not.

Using Layers as a Quick Contrast Fix

Every once in a while I get a really "flat" looking color image and no matter what I do I cannot get the contrast I want. When this happens, I take the following steps:

1. I duplicate the image (in Photoshop Elements or Photoshop CS) by going to File > Duplicate.

2. Next, I convert the image into black and white. You can very easily change a color image into a black-and-white image by going to the Image > Mode > Grayscale. If you then think it needs a bit of adjusting for better contrast, in Photoshop Elements go to Enhance > Auto Contrast or Enhance > Auto Levels. In Photoshop CS, go to Image > Adjustments > Auto Levels or Auto Contrast. This should give you a good black-and-white image.

3. For the purposes of the quick contrast fix detailed here, you will need to layer the original color image on top of this newly created black-and-white image. To do this however, both images must be in RGB Color mode. To select RGB Color mode for the black-and-white image you have created, go to Image > Mode > RGB Color. This will give you an RGB Color file, but the image will still be in black-and-white tones.

Note: You cannot layer an image in Grayscale mode over an RGB file. If you do, both images will turn into black-and-white files.

4. Now save the black-and-white version of your image (designating the new file with the letters BW, for example—Samantha_BW.tif).

5. Then click on the original color image and, while holding down the Shift key, drag the color image over onto the black-and-white image. When you release the mouse and the Shift key, the two images will register perfectly. Check the Layers palette and you will see the color image is now Layer 1 on top of the black-and-white image listed as the Background file.

6. Lastly, play with the blending modes in the Layers palette. Two that usually work for me when I'm trying to boost contrast using this method are the Overlay and the Color blending modes. The result is that the black-and-white image will give the dull color print some density and depth, thus enhancing the contrast.

Hint: Sometimes I also tone the black-and-white version of the image a nice brown to add color depth. See page 82 for details on this technique.

Digital Scrapbooking Projects

Princess Lauren

1. The first thing you need to do when creating a digital scrapbook is to select a picture to start with. Here, I have selected a picture of my grand-daughter, Lauren.

2. Next, open the photo in your image-processing program.

3. Now select a background picture. The Epson website has a wonderful collection of projects and background images for all occasions. Just go to www.epson.com and click on your location. Then, drag your mouse over the Learn & Create tab and select Craft Projects from the drop-down menu. This will take you to the Epson CreativeZone, where you can choose from a variety of project templates.

Note: It is a good idea to print out the directions from the Epson website on how to download and create with their backgrounds. They do change the site every so often, and some things (such as specific menu names) may have changed since I used their site for these projects.

4. After you select your background, look for the Download Project list. Here, you will find all the related items available for download based on your selected background theme. Click on "Win" if you have a PC computer; click on "Mac" if you have a Macintosh computer.

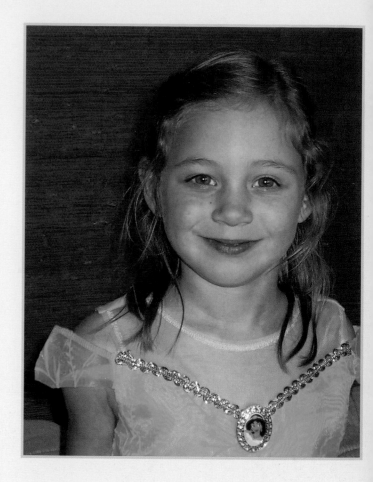

5. When a popup window with the option to save appears, choose where on your computer you'd like to save the files, then click Save. You will see the download progress box appear and you can watch the status of the download.

6. The compressed file will appear in the location you saved it to, and you will then need to uncompress the file by clicking on it (see image A). After the file is uncompressed a folder that looks like the one in image B should appear.

7. Now click on the uncompressed folder and select your desired background image. Here is the background I chose (image C).

a

b

Place photo here.

c

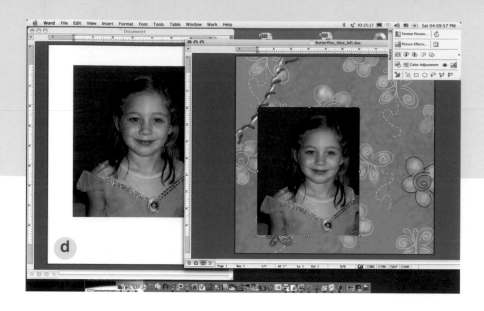

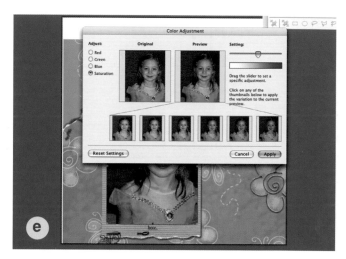

Note: Refer to the directions that come with the project for details and instructions on how to print using the downloaded items.

8. The next step is to insert the picture you chose for your scrapbook into the background you selected. When you click on and open your background, it should open in Microsoft Word. Click on the program's File tab, then scroll down to New Blank Document. Now click on the Insert tab, scroll down to Picture, and select From File (if the picture is already on your computer; select From Camera or Scanner if that is where the image is located).

9. Once the picture appears in the Word document, go to the dialog box on the top right of your desktop and click on Format Picture. When another dialog box appears, click on the Layout tab, then select In Front of Text.

10. Next you'll need to select how you wish to align your photograph (Center, Left, Right, etc.), then click OK.

11. Now copy and paste your image into the background layout. To do this, click on the picture once, then click on the Edit tab and scroll down to Copy. Next, go back to the background page and click on it. Move the sizing bars to where you wish them by placing the white hand over the squares until it turns into a square-moving icon. Then click and drag until the box reaches the size you wish the photograph to be. Click on the Edit tab again, only this time scroll down to Paste. The image may take a minute or so to appear (image D).

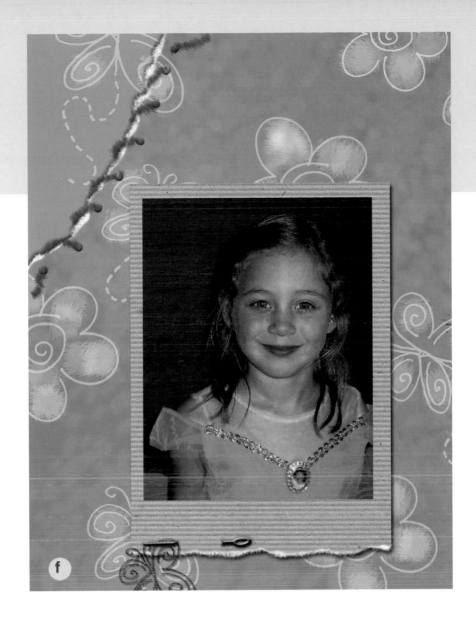

12. If your image looks a little light or needs more color at this point, click on it and make sure that the selection box around the image is visible. Then click on the Format tab and scroll down to Format AutoShape/Picture. Select Color Adjust from the menu that appears. The Color Adjust function allows you to add or subtract color (image E).

13. If the picture is too dark or too light, click on the Format tab, scroll down to Format AutoShape/Picture, then click on the Picture tab. Here, you can adjust the brightness of your image. Again, make sure that the selection box around the image is visible before you go into to the Format AutoShape/Picture menu. (If it isn't, click on the picture and the selection box should appear.)

14. Once you've adjusted your image to your liking, click on the space outside of the picture and the selection box will move to the background layout page. You can change the background by filling it with a color of your choice and selecting the degree to which the color is added. To do this, click on the Format tab and scroll down to Format AutoShape/Picture. From there, select Color and Lines. Here is the final result of the scrapbook page I created using the photo of my granddaughter, Lauren (image F).

Mom and Dad's Wedding

1. Here is the original photo of my parents' wedding, taken in 1940 (image A). As outlined in the Princess Lauren project on page 16, I used the Craft Projects section of the Epson website to work on this piece. From the Projects list, I clicked on Restoration, then selected Heritage Pages.

2. Under the Download project list, I selected my computer type for each item and downloaded the various project options.

3. Once I had downloaded all the necessary project files, I selected a background template called #2 Neutral 1 from the Heritage pages to go with the old wedding photo.

4. I then took the old photograph of my mother and father's wedding and inserted the photo into the template (see the instructions on page 18). The background I chose complimented the photo beautifully, and I was very happy with the results (image B).

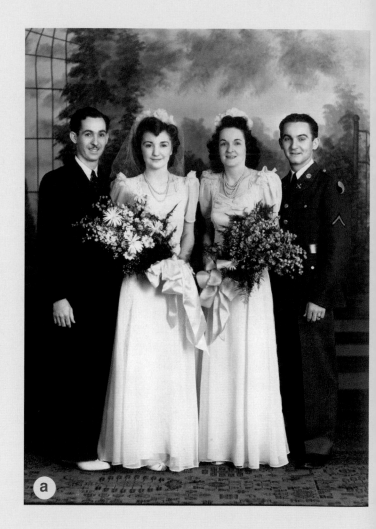

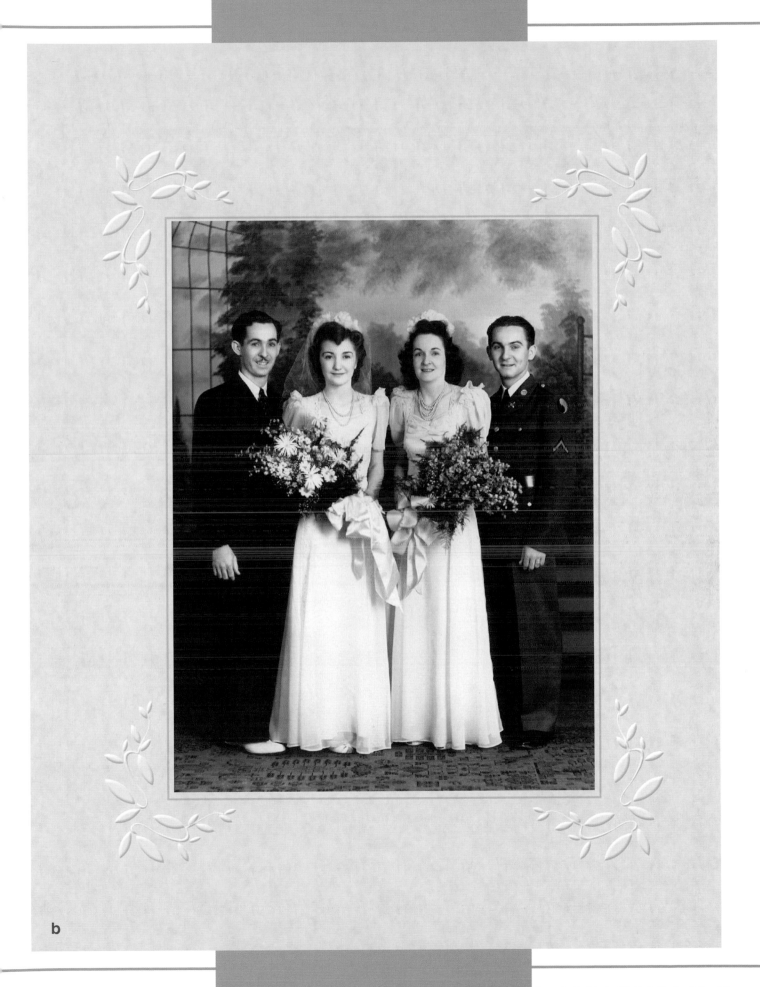

b

Changing Backgrounds

Samantha on a Flowered Background

Have you ever had a photograph where you absolutely love the way the person was captured, but the background is just terrible? This was the case with this shot of my granddaughter, Samantha (image A), so I decided to cut out the existing background and try to place the image of her onto a more artistic background. Before I did this, however, I adjusted the image to my liking.

1. I opened the image in Photoshop and lightened it a bit using the Hue/Saturation menu selection. To do this, go to the menu bar and select Image > Adjustments > Hue/Saturation. (Or, in Photoshop Elements, select Enhance > Adjust Color > Adjust Hue/Saturation.) When that dialog box pops up, move the Saturation slider to the left, reducing the color a bit. Then move the Lightness slider to the right a bit to lighten the image overall.

2. This is a watercolor painting that I did a few years ago and scanned to create a digital image file (image B). I opened the watercolor image in Photoshop, then lightened it a bit using the Hue/Saturation selection, as outlined in step 1.

Hint: Experiment with creating interesting backgrounds by photographing small portions of your artwork, snapshots, or even interesting fabrics or textures in your home. It helps if you have a macro setting (or a macro lens) on your camera, but you can always photograph a larger piece and crop it down later in the computer.

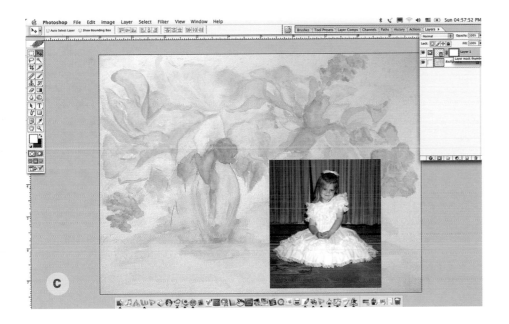

C

3. Once you have a background selected, make sure that it is the same resolution as your image. To do this in Photoshop CS, go to Image > Image Size. In Photoshop Elements, go to Image > Resize > Image Size. Do this with both your background image and your main image and match the ppi resolutions to each other. If one is higher than the other, you will need to match the higher-resolution image to the lower resolution unless you wish to interpolate up the low-resolution file (see page 13 for details).

4. Set the dimensions for your background image to be slightly larger than the subject image size so that you have plenty of room to arrange it where you wish. (Once you have flattened the image, you can then crop it down to your size of choice.) For example, if your subject is 4 x 6 inches (10.16 x 15.24 cm), make your background image 8 x 10 inches (20.32 x 25.4 cm).

5. With both files lightened a bit and resized, I hit the V key on my keyboard to activate the Move tool and dragged the picture of Samantha over onto the painting image, placing it where I wanted it (image C).

6. In the Layers palette in Photoshop CS, click on the icon at the base of the palette that shows a circle inside a rectangle. This will create a mask on the subject layer. Click on the mask in the Layers palette to make sure that it is highlighted (active).

7. Now go to the toolbox and select the Eraser tool. Use the Eraser tool to paint out and paint in information when the layer mask is highlighted and active. When the Foreground square in the toolbox is black, the Eraser tool will erase information from the layer mask (in this case Samantha photo); when the Foreground square is white, the Eraser tool will "paint" back previously erased parts of the image (image D).

8. Once you have erased as much as you want of the background on your main image, hit the V key to activate the Move tool again and adjust the placement of your picture to your liking.

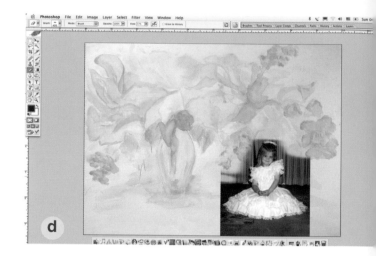

d

Hint: You can toggle back and forth between the Eraser tool functions (i.e., "painting" information back in or erasing it) by hitting the X key on the keyboard.

9. This is a good time to save your work. If you are not finished working on the image, save your "work in progress" as a layered file. It will take more space up on your hard drive, but you can go back to it and rework it later. I usually put an "L" after the project name so that I know that I have not yet combined the layers. If you are finished with the image, go back to the Layers palette, click on the arrow next to the word Layer, then scroll down to Flatten Image. Now the entire piece has been combined into a single layer, and will take up less space on your hard drive when saved.

Caution: Make sure that you are working on the layer mask, not the actual image. If you erase parts of the actual image, you will not be able to use the Eraser tool in the white foreground mode to "paint" parts of the image back in.

Hint: You can adjust the size of the Eraser tool by toggling back and forth between the [and] keys on the keyboard (the two keys just right of the P key).

Caution: Once you flatten the file, save, and close it, it will not open as separate layers again; it will open as a single, one-layer image.

10. Here is the picture of Samantha combined with my watercolor painting (image E).

11. Here is a second version of the image where I cropped in closer around Samantha (image F).

12. I liked the cropped version, but decided that it needed a frame. To add a frame, go back to the toolbox and click on the Background square. When the Color Picker dialog box appears, go into the image with the cursor (which becomes an eyedropper), select a color for the background from within the image, and click OK. (You may also choose to select a color from the Color Picker.) I chose a nice shade of pink from the Samantha image.

13. Then, in Photoshop CS, go to the menu bar and select Image > Canvas Size. In Photoshop Elements, Select Image > Resize > Canvas Size. I added one inch around the image, and the piece reopened with a one inch pink border that I felt set it off just right (image G).

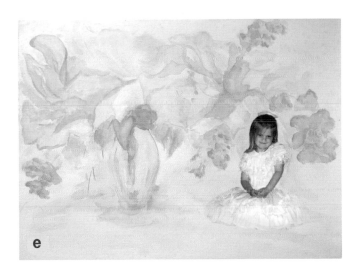

e

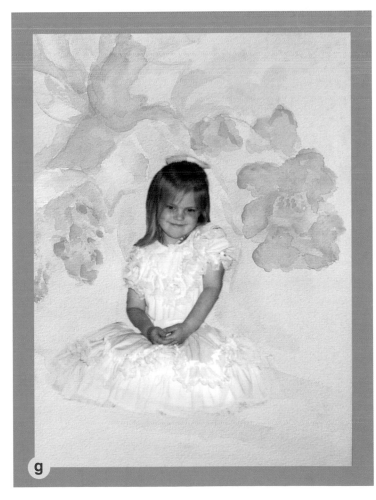

g

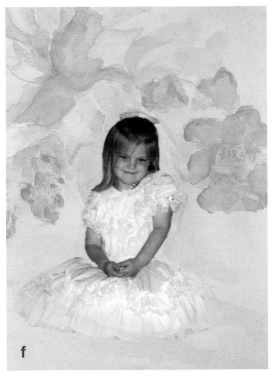

f

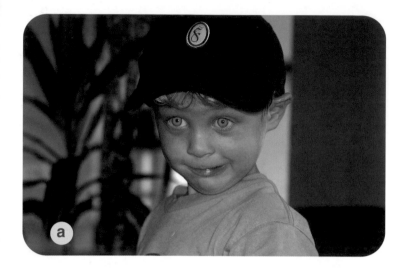

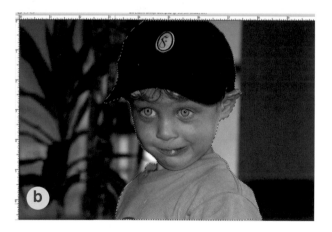

In this example my grandson Liam was wearing his dad's baseball cap and making a silly face, and I thought he looked great! To me, the photo really captured Liam's personality, but the plant in the background was very distracting (image A). So, I decided to experiment with placing this cute shot of Liam against other, more interesting backgrounds.

1. To start, I opened the image in Photoshop Elements and used the Magnetic Lasso tool to create an outline around his head and shoulders (image B). You can start the outline anywhere in the picture, and when you connect the beginning lasso square and the final square, it becomes a selection. You can then move the selection where you wish it.

2. I then set out to try the image against several different backgrounds. First, I decided to create a solid-colored background file using Photoshop Elements. With the original photo of Liam still open, I went to the toolbox and clicked on the background square. Two things happen when you do this—your cursor turns into an eyedropper and the Color Picker dialog box appears. You can then use the eyedropper to sample an existing color from the image, or you can go into the Color Picker with the eyedropper and select a color there. I chose a blue from Liam's shirt for the background color.

3. Next, I went to File > New to create a file with the background color I had chosen. When the dialog box popped up (image C), I named the file and entered in dimensions of 8.5 x 11 inches (21.59 x

Hint: When using the Magnetic Lasso tool, the secret is to go slow, following the edge of your image carefully. Also, be sure to connect the starting square point to the ending square point so that the entire outlined area is enclosed.

c

27.94 cm), which gave me plenty of room to work with (even though I planned to crop the background for the final image). I set the resolution to 300 ppi because that was the resolution of the Liam photo. Lastly, I selected RGB Color mode, clicked on the circle next to Background Color, and clicked OK.

Note: Always make sure that the background and the image have the same resolution.

4. When I clicked OK, a new file appeared in the shade of blue I had selected (image D). I then clicked on the Move tool to drag the Liam selection over onto this new blue file.

5. Since the top of Liam's cap was cut off, I placed the image at the top of the blue page I had created (image E).

6. Once the image was placed where I wanted it, I flattened the two layers by going to the Layers palette and clicking on the arrow icon across from the word "Layer," then scrolling down to Flatten Image.

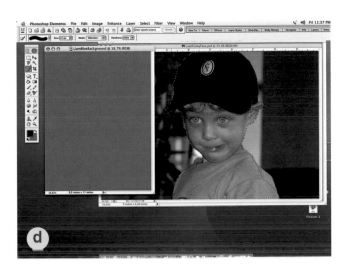

d

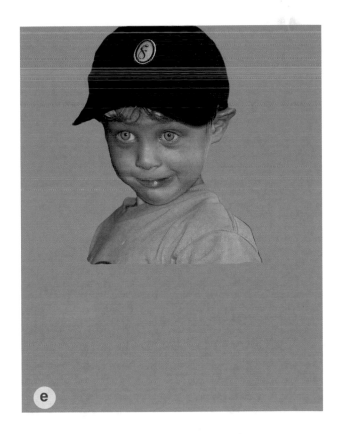

e

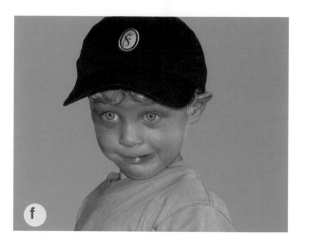

Perfecting Your Selection with the Clone Tool

You may have to "clean up" some information that was carried over onto the new background along with the image selection. In other words, if your selection wasn't perfect, there may be some stray edges or colors that don't belong in the final image. In my selection of Liam, for example, there was a bit of a white edge along the right side of his face. To correct this, I selected the Clone tool. Then, I chose a hard edge brush. To do this, click on the Brush drop down menu that appears next to the Clone tool icon above the toolbox. Scroll down until you find a hard edge brush that will work for you.

Once I had the brush I wanted, I carefully cloned out (i.e., covered up) the stray edge with blue background information. To pick up blue information to be deposited in place of the stray edges on the selection, take the cursor and place it inside the area you wish to sample (the blue background, in this case), hold down the Option key on your keyboard, then click the mouse. This will tell the Clone tool what color material to use to stamp out the unwanted parts of the image. Now release the Option key, go to the area that needs to be cloned out, and deposit the cloned information over any stray information from the selection area by clicking where you want the changes made.

7. Lastly, I used the Crop tool to cut out the extra background space that I didn't want as part of the final image (image F).

Hint: When using the Clone tool, enlarge the area you are working on by using the Zoom tool (magnifying glass icon). Getting in close will allow you to readily see what needs to be cloned.

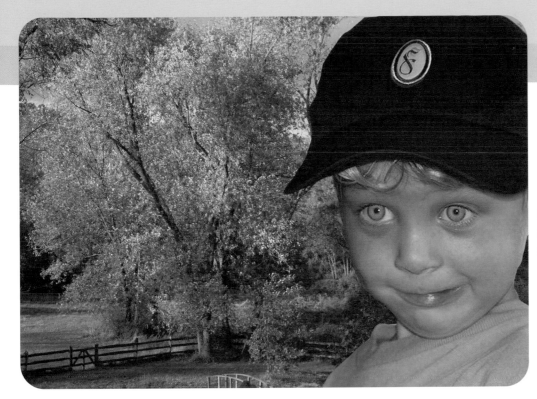

Here, I placed the Liam selection on top of a wooded background.

I also placed my Liam selection on top of a photo I had taken at an aquarium. In experimenting with different backgrounds, I tried to match his expression with different backdrops. Just play around with various combinations until one feels and looks right to you!

Chapter Two: Inkjet Transfers

Inkjet transfer (also known as pigmented ink transfers) are a fun and easy way to transfer your favorite images onto artist papers, fabric, and wood. No harsh chemicals are involved—just plain water. It's easy on your health and easy on your pocketbook!

Personally, I love the look of transferred images. The transfer gives a certain "old world" or "vintage" look to the image that cannot be achieved by printing directly onto paper. When creating a transfer, the inks are not evenly received by the substrate surface (i.e., your fabric, artist paper, etc.). You can actually choose which part or parts of the image you wish to transfer more fully or clearly by rubbing or placing more pressure on those areas. If you wish the image to fade out on the edges, just rub less vigorously or not at all in that part of the print.

Note: When it comes to image transfers, what looks "good" is completely subjective. Some people want as complete a transfer as possible, while others may like the ambiguous feel of a partial transfer. You must decide for yourself what is acceptable for your artwork, and that may even change from piece to piece!

Transfers are one of a kind and vary according to the substrate you're transferring to, the pressure that you use when rubbing, and which parts of the image you choose to rub in. Inkjet transfers give you more options in terms of what substrate surfaces you can place your images on. For example, not all printers are capable of printing onto heavy watercolor papers; the inkjet transfer process enables you to get your images onto these types of artist papers without the risk of ruining your printer heads.

There are many interesting artist papers to choose from for your transfer: watercolor papers, printmaking papers, and various exotic papers. Whichever you choose, choose wisely; always work with a high quality paper to insure the greatest degree of light fastness (i.e., fade resistance) and less deterioration as time passes. Of course, you may also wish to use fabric or wood as your substrate—the possibilities are many. Inkjet transfer is a great way of creating unique images. I hope you have as much fun as I do exploring and using this technique!

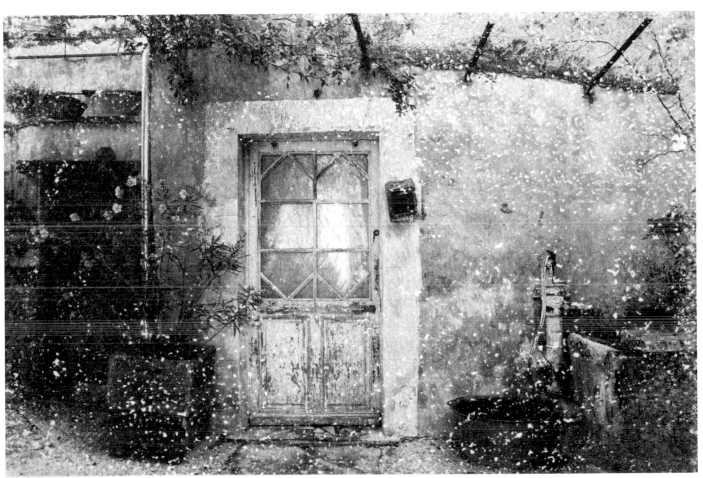

I made this transfer by printing the image onto International's Jet Print Photo, Everyday Soft Gloss, then transferring it onto Arches' Cold Pressed Watercolor paper. The speckling caused by the texture of the watercolor paper gave the image a time-worn look.

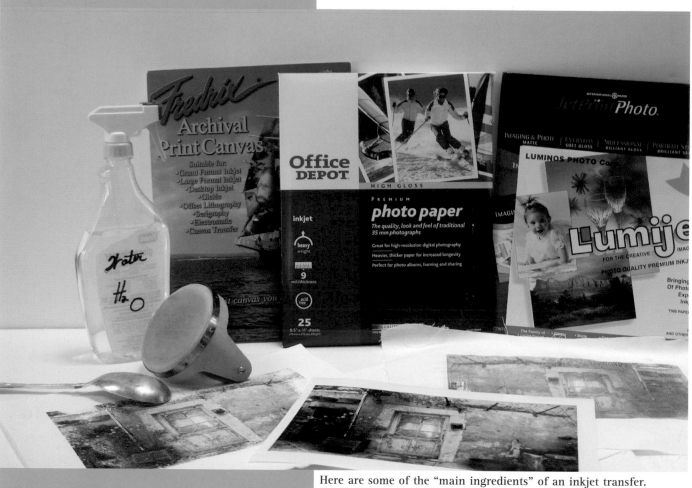

Here are some of the "main ingredients" of an inkjet transfer.

Inkjet Transfer Basics

In this section, we're going to start out looking at some of the basic information you'll need to keep in mind when you go to do an image transfer. This includes what materials you'll need, understanding the transfer process, what kinds of papers and inks to use for your transfer, and when to use gel medium. We will also go over the important role humidity can play in the quality of the transfer.

This transfer was made using glossy inkjet paper and pigmented inks in a Canon WP 6400 printer. The image was then transferred to BFK 140 lb. print-making paper. With these particular inks, do not spray the glossy print, as it will make the inks run. Simply spray down the substrate and lay the print face down on the wetted surface. The inks work very well for transferring.

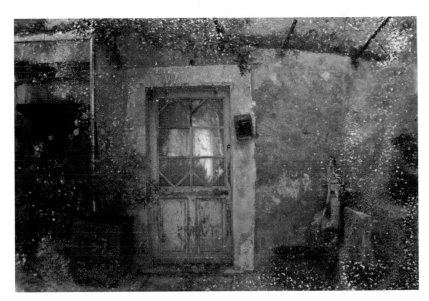

Materials

The following is a comprehensive list of the materials that you will need in order to do an inkjet transfer:

1. An inkjet printer and pigmented inks: I use both an Epson 4000 printer with their Ultrachrome Pigmented Ink Set and an Epson C86 printer with their DURABrite inks. I have also used the Canon inkjet printers with their pigmented inks, which are lightfast and transfer very well. Almost any printer that can use pigmented inks will do.

2. A spray bottle full of tap water: Both the image printed on glossy paper and the substrate of your choice (paper, wood, or fabric) need to be sprayed with water to facilitate the transfer.

3. A baren: A baren is a tool used for rubbing or applying even pressure. A company called Speedball makes a good one; it has a round, flat, fiberglass bottom with a handle across the top that distributes the transfer of information evenly. You can find a baren at your local art supply store, or you can try using the back of a large spoon. If you use the back of a spoon, be sure to rub evenly and not too hard in any one direction or you will end up with streaks of unevenly transferred information.

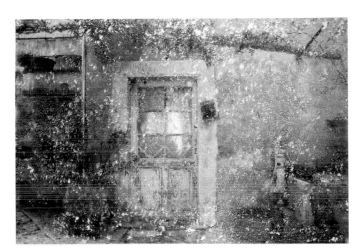

I made this piece by printing the French Porch image onto Lumijet clear film and transferring it to dampened Arches' 88 Waterleaf paper. I used a baren to rub the information into the paper fairly uniformly so there wasn't any fading at the edges.

4. A clean cloth: You will use the cloth for absorbing excess water, as well as to rub the back of the print when the initial contact is made.

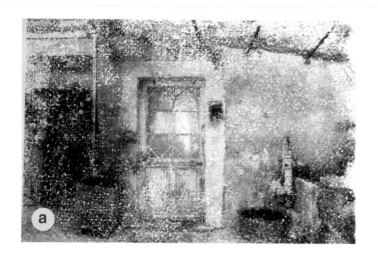

For this piece, I printed my image out onto Fredrix Polyflax/Cotton blend canvas rather than using glossy inkjet paper or clear film. To transfer canvas images, you must use a baren and rub very vigorously on the back of the print. Be sure to spray down the canvas image and the receiving paper well with water. In this case, I transferred the image onto Arches Cold Pressed Watercolor paper (image A). I also really liked the look of the canvas after the transfer was made (image B); enough information stayed on to make it an interesting piece in it's own right..

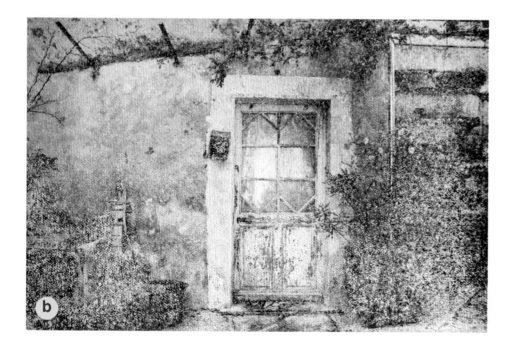

Note: Be aware that not all brands of glossy inkjet paper will work for this transfer technique. Value brands are much more likely to work than high-quality name brands. You may want to buy a few small sample packs of paper to see what works best before investing in a large quantity of any one particular brand.

5. Glossy or Soft Gloss inkjet paper and/or clear film: This is what you will print the image on in order to transfer it to your chosen substrate (see number 6). Some papers that I know work very well are International Paper's JetPrint Soft Gloss, and Fredrix Archival Print Canvas. Two good sources for clear film are www.kimototech.com and www.oceusa.com. They both work well. You can also coat your own film with inkAID (www.inkAID.com), but it's more labor intensive."

6. Artist papers, fabric, or wood: These are the substrates that work with this technique. The text that follows will offer you more details about how to select a transfer substrate.

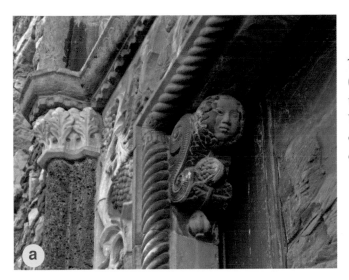

The original Taormina Gargoyle image (image A) was printed onto glossy paper then transferred onto 300 lb. CP Arches' Watercolor paper. Then I painted it and collaged it with paper containing small bits of bark (image B).

Choosing a Paper Substrate

The receiving paper you choose to transfer onto will affect the "look" of the image. The rougher the texture of the paper, the less detail from the image will come through. Conversely, the smoother the paper's surface, the more details will transfer. If you use a "cold pressed" or "rough" textured watercolor paper, they will take the inks less evenly than the smoother surfaces of "hot pressed" watercolor paper or "waterleaf" paper. I use both Arches' and Fabriano's watercolor papers. I also use printmaking papers such as Arches' 88, which is a waterleaf paper, and Rives' BFK. Printmaking papers generally have little or no sizing, which makes them very absorbent.

Note: Sizing is a glue, starch, gelatin, or rosin that is added to paper to make it resistant to liquids such as paints, inks, or water. Papers without sizing are very absorbent and will "suck up" inks nicely during image transfer.

Wood Transfers

If you would like to transfer an image to wood, you can find nicely finished pine plaques at arts and craft stores, or purchase plywood at the hardware store. The important thing is to have a relatively flat, smooth surface upon which to work. Wood grain makes a nice background for images

a

with landscapes or trees, and it is a sturdy, strong substrate for adding elements to if you plan to make an assemblage or collage. Transferring images to wood also allows you to hang the piece "as is" instead putting it under glass and frame.

Note: "Assemblage" implies the use of three-dimensional objects on the substrate surface, not simply thin papers and pictures as would be the case with a collage.

For this transfer I printed my image onto Lumijet clear film and transferred it onto dampened wood, using the back of a large spoon to vigorously rub in the inks (image A). Image B shows the finished wood transfer.

b

a

Fabric Transfers

The best fabric I have found to use for image trans-
fers is plain white cotton. (Men's handkerchiefs
work well.) However, I am sure there are some fab-
rics that I have not tried that will work equally
well. Fabric image transfers give you flexibility and
flow in your art project. When transferring to fab-
ric, I like to choose an image that also "flows,"
such as a woman in a beautiful dress, children
playing in the ocean, lovely flowers, or other
images of a more delicate nature. If you transfer to
fabric you can hang the work in the style of a
scroll, or frame it in a cradle frame to sit on a shelf
with a light source behind it to emphasize the
translucent quality of the fabric.

For this project, I printed my image onto glossy inkjet paper
and transferred to wet cotton. When spraying fabric before a
transfer, you don't want to soak it. It should be wet, but with
no excess water on the surface. I usually smooth out the air
bubbles with my fingers and flatten the fabric out by blotting
it with a dry cloth. In this example, the back of the print had
to be rubbed quite vigorously to get it to transfer. Here, you
can see the transfer backing being pulled from the fabric
(image A) and a close-up of the finished transfer (image B).

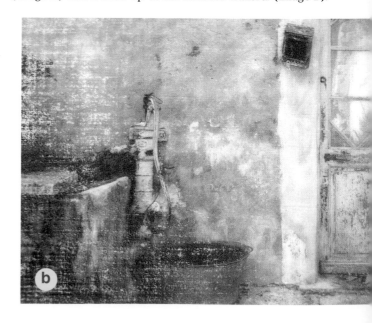

b

Dye-Based vs. Pigmented Inks

Certain types of inks will transfer with water, while others will not. Dye-based inks will frequently leave behind a color cast (an unwanted color shift) on the transferred image. Some dye-based inks will transfer with water but will not transfer all of the image colors; the greens and blues do very well, but the reds and yellows often don't come through. You may find a dye-based ink that works perfectly in combination with a certain paper, but I have found that pigmented inks work best and are much more reliable, so I stick with them.

I made this transfer by printing my image onto glossy inkjet paper with dye-based inks instead of my usual pigment-based inks. The blues and greens transferred very well onto the dampened Fabriano's HP (hot pressed) watercolor paper, but the warm tones (reds and yellows) did not (image A). The warm tones that didn't transfer remained on the glossy inkjet paper after the transfer (image B).

Working with Weather

You may not have considered that the weather could be a factor in quality of your artwork, but it is important to be aware of the level of humidity in the air when you are working with image transfers to paper substrates. Is it a humid day, or a dry day? If you are working with artist papers, it is best to work on a humid day as the papers you are working with will be swollen with the humidity and will more easily accept the inks. If it is a dry day, the papers will require more water in order to accept the transfer and more time for the water to evenly moisten the paper fibers.

Gel Medium

On artist papers that are thin or fragile (especially handmade papers), I use a gel medium to coat the paper. This makes the transfer easier and helps to prevent the paper fibers from pulling up from the surface when the transfer backing is removed. Coat the receiving paper with the gel and immediately place the wetted transfer paper face down and begin to rub (see page 47 for detailed transfer instructions).

Note: If you use a gel medium on the receiving paper to facilitate the transfer, the gel will dry out far quicker if the air is dry than if it is humid. You may need to apply it more thickly in these circumstances.

I Know the Basics... Now What?

Now that you understand a bit more about image transfers, the next thing you'll need to do is select an image that you want to transfer. You may have an image from a digital camera that you'd like to use, or perhaps you have an old print or negative that you think would be just perfect for your transfer project. All you need now is to get your image into the computer and ready it for printing!

Digital Camera to Computer

You can download images on your memory card directly from your digital camera into the computer using a USB or FireWire connection. (You should have a cord that came with your camera that can connect to the corresponding port on your computer.) Or, if you have a card reader (which stays plugged in to your computer), simply insert the memory card and the reader will facilitate the download. You may also have digital camera images saved to CD that you want to use. In that case, just insert the CD into your computer's CD drive and pull up the desired image onscreen.

Flatbed Scanner to Computer

With flatbed scanners you can scan photographs, pieces of art, fresh or dried flowers, a collage that you have made, or even make a collage directly on the scanner's bed using various materials. Once the scanner is activated, the scanner software installed in your computer will likely guide you through the scanning process. (Refer to the instruction manual that came with your scanner for specific details.)

Caution: Be careful not to place sharp or rough objects on the scanner so as not to scratch the glass, and be sure to keep the scanner bed clean and free of debris so that you don't get stray dust spots or specs in your scanned image.

Negative/Transparency Scanner to Computer

You can also use a negative/transparency scanner to scan your negatives or slides. Again, the scanner software should walk you through the process, but refer to the scanner's instruction manual for details if you need to.

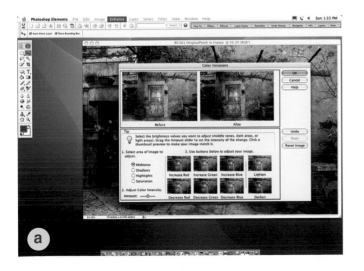

Open and Prepare Your Image

Whichever method you use to get your image into the computer, once it's in, you'll need to open it up in your image-processing program. The first thing to do is check the color and contrast of the image. If you plan to print the image onto clear film (as opposed to glossy inkjet paper), you should also darken the image a bit as it will print lighter.

Note: The following steps are illustrated using the Photoshop Elements and Photoshop CS software programs. If you are using another image-processing software, the commands will most likely have different (but similar) names. You might try using your software's Search or Help function to find specific instructions on how to facilitate the effects described in the following pages.

1. In Photoshop Elements, go to the top of the screen and select Enhance > Adjust Color > Color Variations. In Photoshop CS, to to Image > Adjustments > Variations (image A). Here, you can make the image lighter or darker, as well as add color in the midtones, shadows, or highlights. (Again, if you plan to use clear film for your transfer, be sure to darken the image in this step—see page 34 for more about clear film.) You will see the effects immediately, and if you don't like the results simply select Edit > Undo.

2. The next thing to do is to set the resolution of the image according to what size print you intend to make. If you will be printing at around 8 x 10 inches (20.32 x 25.4 cm), you should set your resolution to 300 ppi (pixels per inch). If you are printing at a smaller size of around 4 x 6 inches (10.16 x 15.24 cm), a resolution of 200 ppi should be sufficient. To adjust your image resolution in Photoshop Elements, begin by selecting Image > Resize > Image Size. In Photoshop CS, select Image > Image Size.

4. 284 ppi is a better resolution for printing than the 180 ppi I started out with, but I decided to round out my resolution to 300 ppi to get the best quality print I could. To do this, I re-checked the Resample Image box and changed the 284 ppi to 300 ppi (image D).

3. Now, uncheck the Resample box. In image B, the image I was working with started out at slightly more than 9 x 12 inches (22.86 x 30.48 cm) with a resolution of 180 ppi. This was larger than the print I wanted to make, so I changed the width to 8 inches (20.32 cm)—see image C. When I did this, the length dimension automatically adjusted to 6 inches (15.24 cm) to match the new width I had entered. The resolution increased to 284 ppi since the image area was made smaller and the same amount of pixels had less area to spread out over.

5. When you are satisfied with your image, select Save As, rename your image so that you recognize it as the size-adjusted version, and save your image to your desktop (or another specified folder).

Note: You may want to save your image as a TIFF file or your image-processing program's proprietary file type (such as Photoshop's PSD file) as opposed to saving it as a JPEG. JPEG is considered a "lossy" file format, which means that it loses a little bit of information each time you save it.

Caution: If you started out with an extremely high-resolution image and need to lower the ppi for printing, be very careful not to use the Save command or you will overwrite the high-resolution file. Always go to File > Save As and rename the lower-resolution version. For example, if you have an image called "FrenchPorch.tif," you might save the lower-resolution version as "FrenchPorch_low_res.tif." This will ensure that your new smaller-sized image file is saved for your project, and your original larger-resolution file will remain untouched.

Make Practice Prints

To save money and prevent wasting a lot of materials, I start by printing out a single sheet of glossy inkjet paper or clear film with several small versions of the image I plan to use to make my transfer. You can get eight small images (approximately 2 x 3 inches, or 5.08 x 7.62 cm) on a sheet of 8.5 x 11-inch (21.59 x 27.94 cm) paper, as seen in the example below.

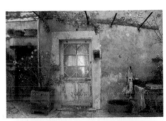
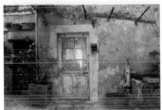
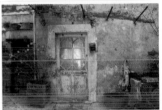
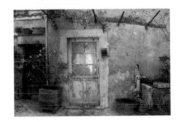
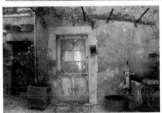
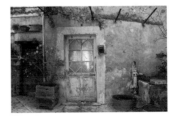
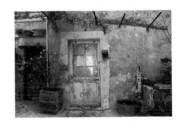

Resizing Your Images for Practice Printing

To resize your image so that multiples can fit on a single sheet for practice printing, take the following steps.

In Photoshop CS:

1. Go to Image > Image Size. Once you have the Image Size dialog box open, make sure you uncheck the Resample Image box.

2. Next, change your image dimensions to approximately 2 x 3 inches (5.08 x 7.62 cm). Note when you do this that the resolution will increase tremendously.

3. Now go back and re-check the Resample Image box and change your resolution to 200 ppi. This is more than enough for a small image.

4. The last thing to do is click on the drop-down menu next to the Resample Image box and scroll down to select Bicubic Sharper. After this is done, click OK.

In Photoshop Elements:

1. Go to Image > Resize > Image Size. Once you have the Image Size dialog box open, make sure you uncheck the Resample Image box.

2. Next, change your image dimensions to approximately 2 x 3 inches (5.08 x 7.62 cm). Note the resolution increase when you do this.

3. Now go back and re-check the Resample Image box, change your resolution to 200 ppi, and click OK.

Hint: If you make a mistake or get confused, just hold down the Option key on your Mac computer, or the Alt key on your PC, and the Cancel button in the Image Size dialog box will turn into a Reset button. Click on it and you will get back your original image dimensions and resolution and you can start the resizing steps over again from the beginning.

Be sure to give your newly resized file a file name that will allow you to recognize and locate it easily, such as Samantha_2x3.tif or Samantha_small.tif.

1. Resize your transfer image to about 2 x 3 inches (5.08 x 7.62 cm) so that multiple images can be printed out onto a single practice sheet. (See the insturctions above for details on how to resize your image.)

2. Leaving your resized transfer image open onscreen, now select File > New. Enter in dimensions that are slightly smaller than the sheet of paper you plan to use for printing. If you're using an 8.5 x 11-inch (21.59 x 27.94 cm) for example, enter in dimensions of 8 x 10 inches (20.32 x 25.4 cm).

Note: When the dialogue box first pops up to allow you to enter your image dimensions, you may have to change the drop-down tab that tells you how the dimensions are being measured from pixels to inches (or centimeters).

Hint: If your Layers palette is not visible, go to Window > Layers. When the Layers palette appears on your desktop, go over and click on the arrow directly across from the word Layers and select Dock to Palette Well. This way, your Layers palette will be conveniently located for future use.

3. Then select a white background and enter in the resolution of your image (i.e., 200 ppi).

Note: The image resolution and file resolution for this new file you are creating must be the same. Be sure to double-check your image resolution before you enter a resolution for this new file so that you are positive they match up.

4. Now select the Move tool from the toolbox (or press Command+V on your keyboard), click and hold your small-sized transfer image, drag it over onto the newly created file, and position it where you wish. Repeat this process and keep dragging the image over and placing it until you have filled up the page.

5. If you need to move the images around once you have placed them, open the Layers palette. You will see all your moved images on separate layers, and the background layer on the bottom will be the new white file page you created. Highlight the layer containing the particular image you would like to move, then go back to the file page and move it around to wherever you wish to place it.

6. After you have filled the page area with multiples of your image, go back to the Layers palette and click the arrow directly across from the word Layers and select Flatten Image. This will bring all your images together in one layer, which significantly reduces the file size and, thereby, the amount of space it will take up on your computer.

Hint: If you cannot tell which layer a particular image is on, go to the Layers Palette and click on the various eyeball icons to the left side of each layer. This will turn the layers on and off until you find which layer the image in question is on. When you click on the eyeball, the image on that layer will disappear; it will reappear when you click the eyeball again.

7. Now go to File > Save As. When the dialogue box opens, save the file to your desktop under a name such as "Test Prints."

8. Once you've saved the file, print the page of images onto your glossy inkjet paper or clear film and cut each individual image out so you can try matching them with your various substrate options.

9. Then take the hot or cold pressed watercolor papers (or other printmaking papers) you have chosen as possible substrates and cut them into small pieces to experiment with the small image cutouts you printed up. Be sure that the pieces of watercolor paper are big enough to fit your image on. If you wish to transfer your image onto a wood or fabric substrate, you can also do so with one of your small images. If it doesn't turn out, immediately wash off the transfer with water.

Note: After washing off a practice transfer from a wood substrate, be sure to wait ten minutes or so to let it dry out before trying another transfer. If the wood is too wet, the transfer will smear. The same is true for practice fabric transfers, but you will have to wait longer for the fabric to dry.

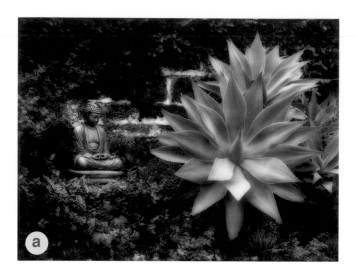

10. If you're trying to decide between multiple paper substrates, transfer your practice images onto the various sample squares you cut out in step 9 and see what paper works best for the look you want to achieve. (Refer to the following pages for detailed transfer instructions.) When you find a winning combination, print out a large version of your image onto a full sheet of glossy inkjet paper or clear film and make your final image transfer using the following section as a guide.

I transferred my Blue Buddha image (image A) to artist paper, then painted it with diluted acrylics (image B).

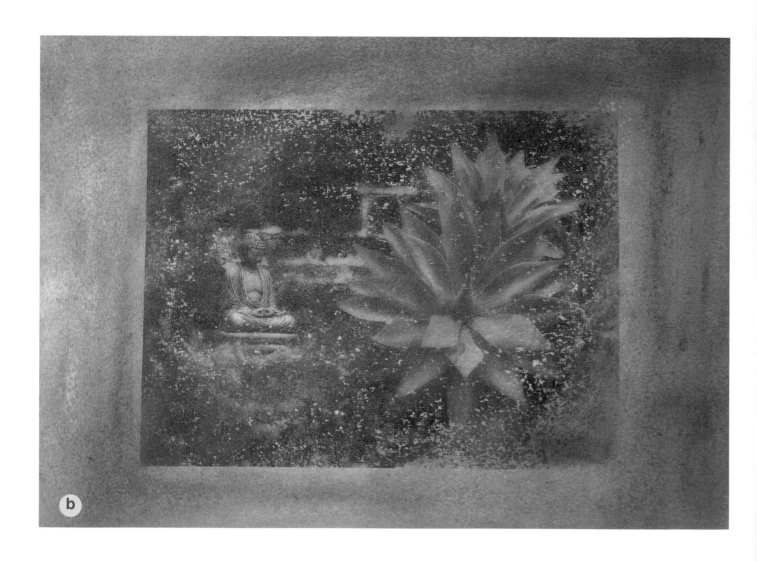

How to Make an Image Transfer

Not every image will make a good transfer. "Marrying" the image with the process is very important. In other words, if you don't foresee the transfer process adding to the mood or impact of the image, there is no reason to waste time and energy doing it. Image transfers can appear "gimmicky" if the substrate and the technique are not well matched with the image. For example, I would not transfer a portrait of a young woman onto wood. The wood texture would not enhance her beauty or smooth skin, but rather diminish it. I would probably choose a lovely smooth paper for the transfer. A shot of a lion, on the other hand, would most likely look very good on a wood substrate. It would enhance the roughness and raw nature of the subject.

Always consider your subject matter when thinking of transferring the image to another substrate. Ask yourself, will the process enhance the image or degrade it? As with all art, what looks "good" or "bad" is completely subjective, so just put some thought into what kind of piece you're trying to create, then experiment to see what you think looks best.

Let's Get Started!

1. To start, open the selected image in your image-processing program.

2. Then flip the image horizontally. In Photoshop CS, go to Image > Rotate Canvas > Flip Canvas Horizontal. In Photoshop Elements, go to Image > Rotate > Flip Horizontal. You can get away with not flipping the image in some cases, but if there is any writing (on a t-shirt, a sign, etc.), you must flip the image in order for the writing to appear correctly when it is transferred. (This makes sense if you imagine the transfer as being the mirror image of the printed picture.)

3. Print the image out onto glossy inkjet paper or clear film.

Note: When using the glossy paper to transfer the image, if you leave the white paper border around the print, it will also transfer. If you prefer the image not to have this white border, cut it off before you make the transfer. You can also wipe the white border off of the substrate with a clean cloth immediately after you make the transfer, but you must be very careful not to wipe away the inks inside the image. Of course, if your substrate is very white, the white print border will not show. Any other shade, however, will reveal the white border unless it is removed prior to the transfer.

4. Select a watercolor or printmaking paper for your substrate.

I made this transfer onto Larroque Fleur Paper using Hahnemuhle's JetPrint Multi-Project Photo Paper, Glossy. Larroque Fleur Paper is a beautiful French paper with flowers embedded in it. The flower inclusions added an interesting effect to the finished print.

Note: When you first start experimenting with image transfers, I recommend that you begin with paper transfers before moving on to wood or fabric because you will have a higher rate of success. Wood and fabric are a bit harder to manage in the learning stage, so get comfortable with paper transfers and branch out to the other substrates from there!

5. Grab the spray bottle you filled with water and spray the receiving paper, making sure it is evenly wet all over the surface. Use your fingers to move the water around. Let it sit for a few minutes, then blot any remaining surface water off if needed with a clean cloth or towel. Don't use a paper towel, as it will leave fibers on the surface.

Note: Whether you're using paper, wood, or fabric as your substrate, when wetting the surface with the spray bottle, remember that you want it to be damp, but not soaking wet. If it is too wet the inks will smear.

This transfer was made using the same materials and baren pressure as the image at the top of page 33, except the substrate paper was wetter. You can see a slight blurring or smearing of the inks. If you like this look, you can experiment with using more water to get a watercolor effect.

6. Now take the glossy inkjet paper or clear film that has your image printed on it and spray it with water until it is wet all over. I usually do this over a trashcan and give it a shake before I place it on the substrate.

7. Lay the print face down on the wetted paper (or wood or fabric) and pat it down with a clean, dry cloth to make sure that it is stuck to the receiving substrate.

8. Then, begin to rub the back of the transfer with a baren or the back of a large spoon. Be careful not to rub too hard; you don't want to move the print. I generally start out lightly and build up to a harder rubbing technique. I also keep one hand pressed against the back of the print to keep it from slip-

ping. I prefer to rub the middle of the print with more pressure and the edges of the print with very little pressure so that they look faded or broken up. Images printed on glossy inkjet paper will transfer quickly, but images transferring from clear film will take a bit longer.

Note: Inks transferred using clear film will take about five minutes to start to dissolve onto the substrate. When you see the inks breaking up or getting crackly—which is easy to see, as the film is transparent—they are beginning to dissolve.

Here, I printed my image out onto glossy inkjet paper and transferred it to Arches' Rough Watercolor Paper. I used a baren to facilitate the transfer. However, because the texture of the receiving paper was so deep, it was impossible to fully transfer all the inks, which resulted in a very spotty transfer (image A). So, I let the transfer dry overnight, then used Faber-Castell watercolor pencils (they can be used wet, but I used them dry for this project) to fill in some of the spotty image areas with color. Then, with wetted cotton swabs, I spread the color out to create an image that looked very much like a watercolor painting (image B). This one is my favorite!

Hint: If you've already pulled away the transfer paper and you notice you have a large white spot of missing information that you do not like, take your finger and "paint" with the inks surrounding it to blend it in. You can only do this for a short time, while the inks are still wet.

This transfer was a complete fluke. I printed the image onto Lumijet clear film and then tried to transfer the image to a white piece of cotton fabric. I dampened the fabric with water, but the inks on the clear film only slightly transferred, leaving the film (image A) with the fabric texture imprinted in the remaining inks. I then took that film and what ink was left on it, sprayed it again with water, and placed it onto wetted Fabriano Hot Pressed Watercolor paper. The transfer came out the fabric texture imprinted on it (image B), a nice touch. Sometimes the flukes are the best ones!

Note: You can use any watercolor pencil to add color to your transfer. I prefer to use Faber-Castell pencils because of the special emulsifier they have that makes them glide onto any surface without tearing the paper. They are especially good to use on fragile papers.

9. After rubbing the transfer onto the substrate, gently pull back the corner of the print to check how the inks are transferring. If there is a large piece of information missing, lay the print back down and rub a bit harder on that area. Peeking at the transfer will help you to see where you need or want to render more information.

10. When you are satisfied with the transfer, pull the glossy inkjet paper or clear film away from the substrate. Remember that this is a very subjective process. You alone can decide when the print is finished and what looks good or not.

Chapter Three: More Fun Printing Projects

Using your images in exciting and unexpected ways is both thrilling and satisfying. In this chapter, we will look at using image transfer to create unique envelopes and memory boxes. Then, I'll introduce you to the world of inkjet fabrics and show you how you can print your images directly onto this unique substrate to create decorative clothing, quilts, pillows, or any other fabric item that strikes your fancy! Lastly, I'll show you how to create a photo collage.

Envelope Art

In the age of Internet and email, letter writing has become a bit of a lost art. But how wonderful it is to receive a letter, hand written or typed out, that you can actually hold in your hands? Yes, of course, you could print out an email, but how many times have you done that? If you are like me, the answer is not often—maybe never.

I have begun to write letters again and decided to make my letters even more special by decorating the envelopes. Now people tell me that they collect my envelopes! When I travel abroad, I take several envelopes with me so that I can post them from all over the world. And don't forget to be picky about the stamp! Choose one that suits the colors and the picture you transferred.

This is a fun project that your friends and family will cherish. Using the glossy inkjet paper transfer technique covered in the last chapter, you can create simple, beautiful, functional art! In the following text, I will explain how to prepare an image for transfer to an envelope using Photoshop Elements. (As always, it is not necessary to have this particular program in order to accomplish the desired effects. Use your software's Search or Help function to learn how to achieve these results with your specific program.) Once you're image is ready to go, simply make the transfer using the steps detailed on pages 47-51 and you'll be mailing art in no time!

1. The first thing to do is buy a good quality stock envelope. The thin paper envelopes are less money, but they will wrinkle when wetted and make the transfer smear and lose information.

2. Next, take the measurements of the envelope you are going to use. The standard business envelope is 4 x 9 inches (10.16 x 22.86 cm).

3. Keeping your envelope measurements in mind, select an image and open it in your image-processing program. You will need to resize the image so that the width matches the width of the envelope. To resize an image, first bring up the Image Size window and check to see what the image dimensions are. To do this in Photoshop Elements, go to Image > Resize > Image Size. In Photoshop CS, go to Image > Image Size. Now, in either program, go

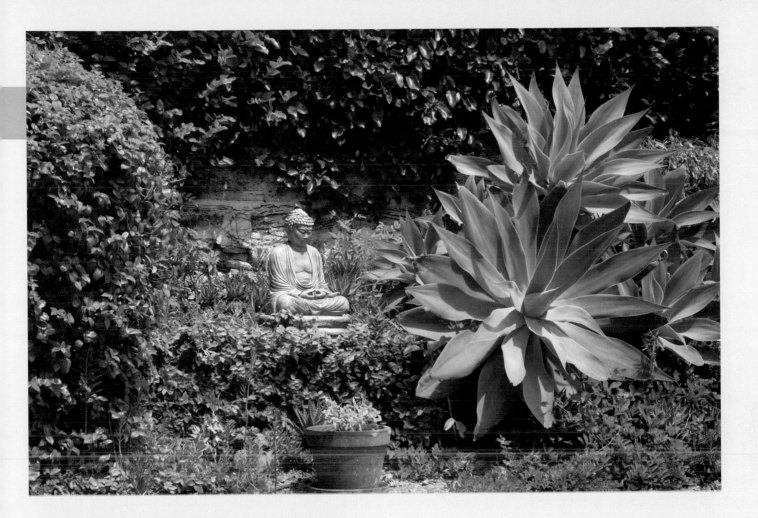

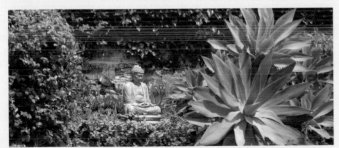

Here, you can see my original Buddha in the Garden image (top) and the cropped version of the image, sized to fit on an envelope (above).

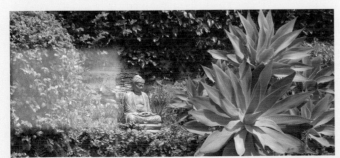

This is the envelope with the lightened area for the address (see steps 5-7).

to View > Rulers. This will bring a ruler edge around the image. Select the Crop tool from the toolbox and crop the image as close to the envelope's dimensions as possible. Don't worry if the measurements aren't exact, as you can always paint over any the white space on the envelope later.

4. Once you have an approximately measured area of the image selected, you can move the selection around by grabbing the center of the cropped area with your cursor. When you like the composition, double click inside the cropped area and the crop will be applied (or, go to Image > Crop). Now you have a perfectly sized image for your envelope!

If there is a large space in your image, you may not need to create a lightened area for the address. In this image of St. James Court rooftops, for example, I used the sky as the address space.

Note: Remember that the transfer will be a mirror image of your original. If you wish it to look exactly like the image on your monitor, you will have to flip it horizontally before printing it out for transfer. (See step 2 on page 47 for details.)

5. Next, select the Rectangular Marquee tool from the tool box and section off a rectangle for the address space. You can put the address box anywhere on the image that you like, but remember that its placement will be reversed when the image is transferred; if you want it to end up on the right side of the envelope, you will need to place it on the left (unless you plan to flip your image before printing).

6. Once you have the address space selected, go to Select > Feather. Set the radius to be around 20 to 25 pixels, then click OK.

7. Now you need to lighten the area you've selected for the address space so that the address you write on it will be readable. To do this in Photoshop Elements, go to Enhance > Adjust Color > Adjust Hue/Saturation. In Photoshop CS, go to Image > Adjustments > Hue/Saturation. When the dialog box appears, grab the Lightness slider and move it to the right, making the area very light, almost transparent.

Here is an example of an image transferred onto a plain white envelope.

This is the transferred image after painting on the envelope to fill in the white space.

For this image, I scanned a collaged piece, resized the image so it would fit on an envelope, then flipped it horizontally and printed it out on glossy paper for transfer.

Here is another example of an image transfer onto a white envelope.

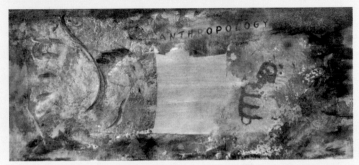

Here, the image is shown transferred onto an envelope. I did not apply any additional coloring.

This is the transferred image after I applied paint.

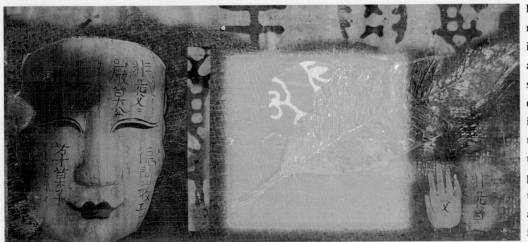

Before I transferred this image, I manipulated it in Photoshop, changing the color of the mask and adding various elements, such as the skeleton leaf and the hand. I dragged these over onto the mask image using Layers. After flattening the image, I then flipped it horizontally and printed it out onto glossy paper for the transfer. When the transfer was complete, I selectively added some acrylic paint to pull the image together.

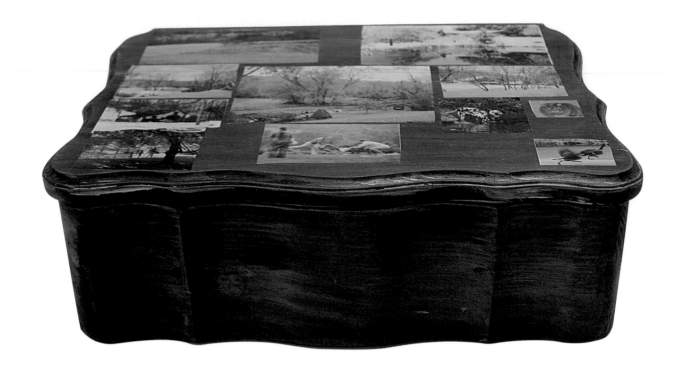

Making a Memory Box

Memory Boxes are an excellent way of using and displaying all those loose photographs that you have laying around the house. Even if you do have your photos nicely organized in an album, just how often does anyone take the time to open and look through them? Memory boxes are an eye-catching, alternative way to show off your pictures.

I created the memory box I use as the main example in this section as a Christmas present for my husband. I had asked our children and grandchildren to write a letter to "Poppy" explaining how much he meant to them and we placed the letters inside the box. It was the highlight of the day! The box now sits on his bureau. He uses it as a letter box and sees it everyday, enjoying many fond memories.

There are many different themes you could choose for a memory box. If you want to make one for a child, you might include shots of them playing sports, their pets, friends, and family. For adults, you might include photos of their favorite places or activities. You could make it into a sewing box, a cigar box, or a collector's box for odd bits. The possibilities are endless, and believe me, a memory box gift will be greatly appreciated and cherished.

Let's Begin

1. I purchased an unfinished wooden box for this project, then painted it with water-diluted acrylic brown paint.

Note: If I had opted not to paint the box, I would have used turpentine to coat the unfinished wood before I transferred the images onto it. (See the note on page 61 for more details.)

Lazertran Image Transfer Basics

Lazertran decal paper is a wonderful product that opens all kind of creative avenues. Be sure to check out Lazertran's website (www.lazertran.com). They have examples, tutorials, and lots more fun ideas. Using these "waterslide decal transfer papers" is easy and fun. There are, however, some precautions to take depending on which substrates you are working with.

When printing on the Lazertran decal paper, be sure to print on the whiter front side (the back is a greenish tone). The following printer guidelines will work with most printers, but you may need to run a test print on your printer to get the best reproduction. Use these settings as a base from which to do a test print and then, if you have to, make your adjustments:

• Media Type: Select Photo Inkjet Quality Paper, Luster paper, or Glossy paper. (One of these should work!)

• Ink: Color/B&W photo

• Access the Advanced Settings area and use Fine – 720dpi. Uncheck High Speed if it is checked.

• Color Management: Check Color Controls

• Mode: Photo Realistic

Note: I usually use +2 contrast and +3 magenta because my printer needs a magenta boost, but every printer is different. Make a test print onto your substrate material, then check it to see what you can do in the printer dialog box to make it better, such as correcting for contrast or color, either by adding or subtracting with the sliders.

Materials

To do an image transfer using Lazertran water-slide decals, you will need the following materials:

1. Lazertran inkjet waterslide decal transfer paper

2. Your selected image or images

3. Acrylic matte medium

4. A sponge paint brush

5. Turpentine (if transferring to wood)

6. Varnish (optional)

7. Your selected substrate (paper, wood, tile, stone, or gessoed canvas)

When your printer is all ready to go, double check to see that your image appears as you want it to onscreen, then print! You can print one large print on the 8.5 x 11-inch (21.59 x 27.94 cm) decal paper, or a variety of smaller prints to be used in your collage or transfer piece. (See pages 43-45 for details on how to place multiple small images on a single page.)

Precautions

When working with materials such as turpentine and varnish, always be sure to have proper ventilation. I work with the windows open to get lots of fresh air. I would also suggest wearing surgical gloves so that you avoid contact with these materials.

2. After the paint soaked into the wood, I used Jo Sonja's iridescent green gouache paint, slightly diluted with water, to highlight the brown and give it some depth (image A). When I was satisfied with the color, I let it dry for several hours.

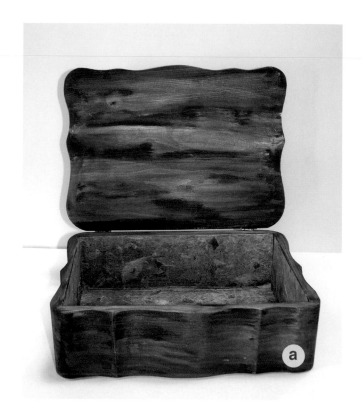

Note: When diluting gouache paint, add just enough water to make the paint less thick and easier to apply. If you prefer, you can use it straight from the tub with no water.

3. While it was drying, I went to the computer and selected images to place on the box. Since I was making a letterbox for my husband who receives interesting cards and mail from all over the world, I chose to decorate the box with images of our family and our home. I opened each of the images and sized them down to anywhere from 3 x 4 inches (7.62 x 10.16 cm) to as small as 1.5 x 2 inches (3.81 x 5.08 cm), making the more important ones larger.

4. Next, I opened a new Photoshop file in by going to File > New. I set up the dimensions to be 8.5 x 11 inches (21.59 x 27.94 cm) at 300 ppi, in RGB Color mode, and with a white background.

5. Then I dragged the sized-down images I had prepared over onto this newly created file. I tried to arrange them so that I was making the most of page area (image B), and when I was finished I flattened the layers. (See pages 43-45 for detailed instructions on how to lay out multiple images on a single page and flatten them into a single layer.)

6. Once I had all the images together in a single flattened layer, I went to File > Save As to name and save my composite file.

7. I then printed the file onto the Lazertran inkjet waterslide decal paper.

8. Next, I cut out the images from the decal sheet and began arranging them on the lid of the wooden box to determine where I wanted to place them (image C). When I was satisfied with the layout, I moved it all to a piece of cardboard in its current arrangement. This way, I would be able to keep the layout in mind as I placed each decal on the box for transfer and avoid wasting time trying to arrange them as I transferred them, and possibly not liking what I had created.

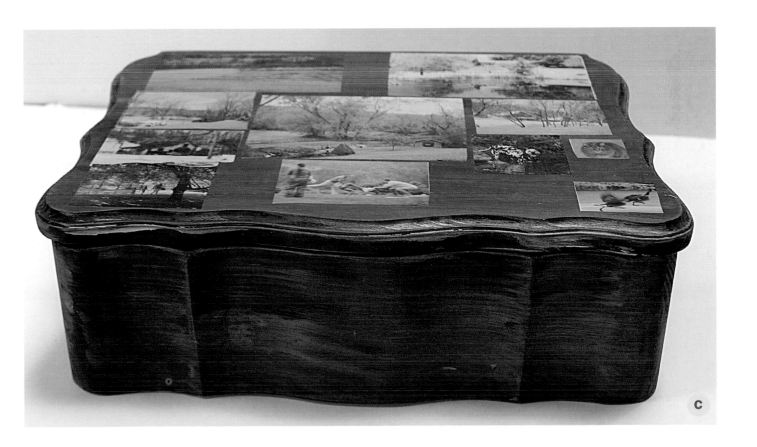

9. I then set up my workstation with a bowl of warm (not hot) water and a small plastic container of acrylic matte medium (diluted with water to be about the consistency of milk), and got my sponge brush.

10. After my workstation was all ready to go, I painted the box with the acrylic matte medium mixture. Since it is easier to work in one section at a time, I painted matte medium on the top of the box lid and concentrated on that first.

11. The next step is to soak the first decal to be placed in the warm water for a few seconds to release it from its backing. It is normal for it to curl slightly.

12. Now lay the decal down on the receiving surface that has been coated with acrylic matte medium (in this case, the painted wood) and use your fingers to smooth it out, getting all the air bubbles out. (You can also use a small roller to do this.) Use a soft cloth to press it down and wipe off the excess matte medium. Repeat steps 11 and 12 for the remaining decals.

13. Once all the images were laid down, I created a thicker mixture of acrylic matte medium and water. (This mixture is thicker than milk, almost like curdled milk.) Then I painted over the entire top of the box and all the transfer decals. Apply the mixture generously, but wipe up any excess medium with a clean cloth when you are done. Don't worry about the whitish look that will occur when you paint the medium on—it will dry clear (image D).

14. In the case of this wooden box, I worked in sections, starting with the top of the lid, then inside the lid, then around the sides (image E). I also

When to Use Acrylic Matte Medium

Coating transferred decals with acrylic matte medium is especially important if you intend to varnish your project. Without the acrylic matte medium coating, when you varnish your piece with an oil-based varnish, the whites in the decals will go transparent, and they will not go transparent evenly! The whites will become streaky and only partially transparent. This transparent effect can be used creatively by applying the varnish evenly and thoroughly and letting it dry before you soak your transfer to release it (in which case the whites will become evenly transparent in your image), but when you do not wish it to happen, it can be a disaster. Think about that nice white shirt disappearing, or someone's white hair. Oops! As long as the decal is coated with the acrylic matte medium, the whites will remain white when varnished.

Of course, if you do want to make the whites in your image transparent so that the background shows through, the best thing to do is coat the decal with an oil-based varnish before transferring it. Give it a double coat to make sure it gets evenly covered. Then, when it is thoroughly dry (this could take from two to six hours according to the weather—the more humid it is, the longer it will take), continue the Lazertran transfer process starting from step 12, in which the decal is soaked in warm water for a few seconds to release it from its backing.

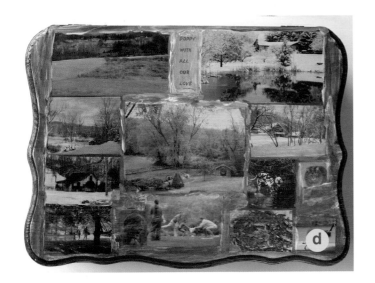

wanted the inside to be nice, so I used acrylic matte medium as glue and lined the box with a lovely Japanese paper that had bark inclusions.

15. When the transfers and lining paper inside were dry (about four hours later), I went back to the box and realized that I did not like the way the images looked. They were too "cut out." So I grabbed my paints and used the same acrylic brown paint and iridescent green paint from steps 1 and 2 to paint in between the images. I used very little water with the paints, just enough to help it spread. When I was satisfied with the look of it, I let it dry overnight.

16. When the box was thoroughly dry, I varnished the entire box with a soft gloss oil-based varnish. As it was very humid when I applied the varnish, it took two days to thoroughly dry.

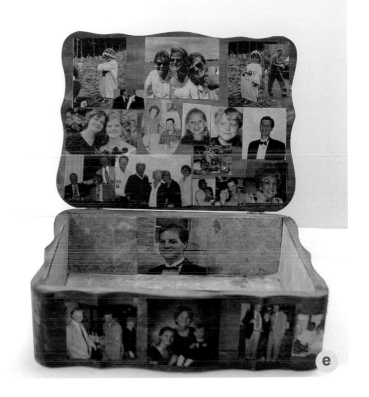

Note: If I had opted to transfer the decals onto the raw wooden box without painting it first, I would have used turpentine to coat the wood before transferring images onto it, then turpentine to coat the box when it was finished. You must use real turpentine and not a substitute. Remember to coat any images you want to preserve the white in with acrylic matte medium before you apply the final coat of varnish.

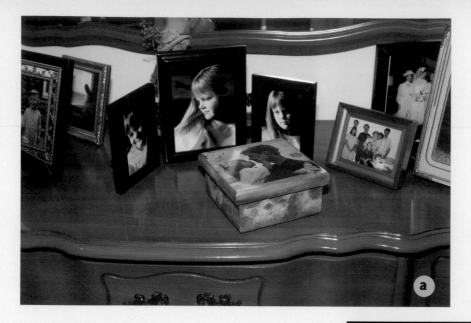

I created this little treasure box (A) for my grand-daughter to show how much she loves butterflies and her daddy. The colors are meant to echo the irides-cent colors of butterfly wings (B). The image of Lauren and her daddy was printed onto Lazertran inkjet waterslide decal paper and transferred to a painted box. Then the butterflies and iridescent paints were added to finish it off (C).

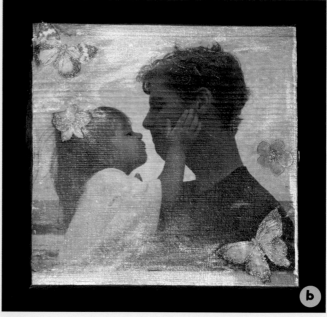

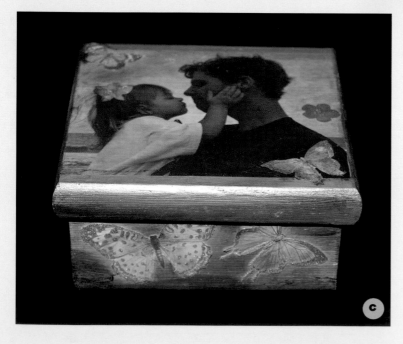

Inkjet Printing on Fabrics

Jacquard has a great line of silk and cotton fabrics made for inkjet printing. They wash well and retain their colors. The Jacquard silk is very beautiful and lustrous, and even retains its "silky" feel after being printed upon. Pigmented inks work best for these products, as the dye-based inks are a bit too transparent.

The Jacquard inkjet fabrics come with a paper backing that peels off after printing. If you want to try using another fabric, cut a piece of paper the same size as your fabric and spray the paper with removable adhesive, or line the edges with removable tape. Then run your fabric and paper "sandwich" through your printer. (This is best accomplished when you can "back load" your papers and it doesn't have to go through the rollers face down in order to print right-side up.) When the print is finished, immediately pull the paper away from the fabric and let it air dry for around five minutes. I have used this technique with very thin exotic papers as well as with cotton and silk. You can run gessoed canvas through your printer without any backing as long as your printer heads are raised up to accommodate for the thicker printing surface.

Caution: Before running gessoed canvas through your inkjet printer, check your printer manual to see if it has a "heavy paper" setting. If you cannot find a setting that raises the printer heads, do not try this, as the heavy canvas will ruin your printer heads and render your printer unusable.

Printing on Cotton and Silk

When you select an image to print on cotton or silk, be sure to increase the contrast and make the print much darker than normal.

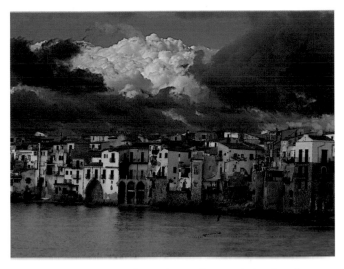

This image is a combination of an original color image with a black and white sketch of the same image (see pages 79-81 for details on this process). I wanted to print this image onto cotton, so I darkened the image and boosted the contrast.

Here it is printed out on cotton and sewn onto a pillow for my sofa. I enjoyed this small village in Sicily very much and have many fond memories of my time spent there. When I go into the living room, I see this scene and it makes me smile.

Printing on Organza

Organza is a new and exciting fabric that is very beautiful and sheer, making it conducive to overlaying on top of another image. Unfortunately, you cannot see the "sparkle" this fabric has in the image reproductions included here, but in reality, the fabric has a shimmering effect that is uniquely attractive. When I overlay an organza image over another print, the organza image seems to move and blend at different angles.

When printing on this semi-transparent fabric, be sure to make your print much darker than you would when printing on paper. I make it even darker than I do when planning to print on cotton or silk, as the inks go right through the material.

Increase the saturation in Photoshop Elements by going to Enhance > Adjust Color > Adjust Hue/Saturation; in Photoshop CS, go to Image > Adjustments > Hue/Saturation. When the dialog box appears, move the Saturation slider a bit to the right. Then make the print darker. You can just move the Lightness slider to the left, or, if you have the full version of Photoshop, however, you can use Curves by going to Image > Adjustments > Curves. Click and hold the center of the curve line and pull it down a bit, which will make the midtones darker.

Here are some examples where I used an image printed on organza and layered it with other paper prints, letting the two images blend together. These images have a dimension and feel that cannot be obtained by simply blending two images together in Photoshop with Layers; one print is on paper and the other is on fabric, and the two prints visually interconnect and give an "extraordinary look" to the final piece.

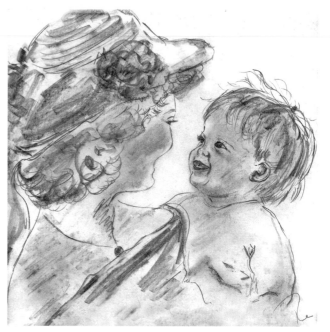

This is a pencil sketch that I drew many years ago of my daughter and granddaughter. I darkened it significantly to prepare for printing onto the organza fabric. (Remember, you can also turn any photograph into a sketch-like rendering. See pages **77-78** for details.)

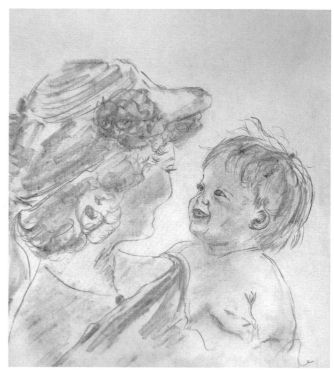

This is the image printed on organza, shown here with a soft buff color mat beneath it. By placing color mats of different colors beneath your organza print, you can change the colorcast of the entire image.

This is an image I had of leaves and a waterfall, slightly adjusted in Photoshop to create a different color tone.

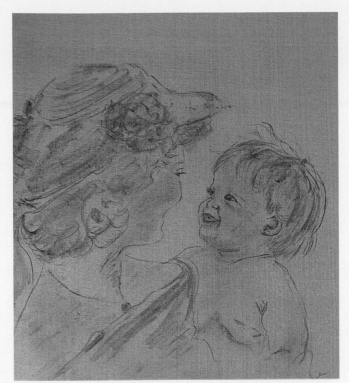

Here is the organza print with a red mat behind it.

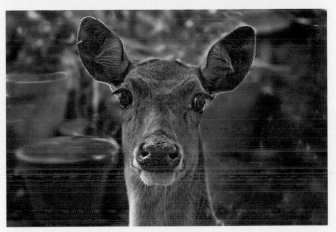

I photographed this deer in Hawaii, then darkened the image in Photoshop to use with the organza.

For this version, I laid the organza print overtop of a color print of flowers.

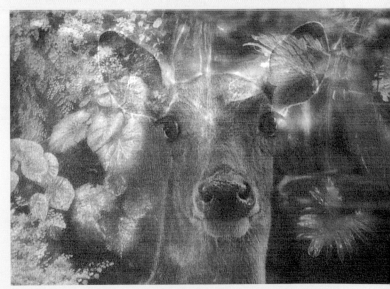

I printed out my deer photograph onto the organza fabric and laid it over the image of the waterfall and the leaves, which was printed out on regular inkjet photo paper. The piece now has a dimensional quality and a softness to it that the original deer print didn't have.

I sized down an image of palm leaves (image C) to fit in the lightened space I had created. I then added a nice golden color around the print (see page 79 to learn how to create a colored border around your images). I knew this would bring out the palm trunks and give them some color when I laid the infrared shot on top.

For this piece, my approach was a bit different. I took a black-and-white infrared shot of palm trees and darkened it a bit (image A). Then, I created a light area in the middle of the image (see page 54 for details) to allow another print to show through (image B).

With that accomplished I then went to Select > Feather and chose a radius of 3 pixels to soften the edges of my selection. I then went to View > Rulers to make ruler measurements appear around my image. If you place your cursor inside the ruler measurements around the print and pull out into the print, a guideline, usually turquoise in color, will appear inside the image. For this project, I pulled out a guideline from each edge to create a center block. I then used the Rectangular Marquee tool to create a 4 x 6-inch (10.16 x 15.24 cm) rectangle in the center of the guidelines.

The infrared palm tree shot was printed onto organza fabric and laid over the color print of the palm leaves, which came through the faded out center rectangle beautifully (image D). The golden color around the leaves gave a nice warmth to the palm trunks. The shimmering quality of the organza fabric adds to the multi-dimensionality of this piece, but as I mentioned earlier, these photographs do not accurately depict that quality.

More Inkjet Fabric Projects

There are so many wonderful possibilities of what to do with your inkjet fabric images. They look great in a frame, as part of an art quilt, or sewn onto a favorite item of clothing.

I printed two images onto Jacquard cotton and sewed them on to my favorite old denim jacket to liven it up a bit (image E). I also added a strip of color from a third image to the breast pocket. These images were printed onto cotton fabric and then attached to the jacket with a product called Stitch Witchery, by Prym Consumer USA Inc. This is a poly-spun adhesive that attaches fabrics together when ironed with a steam iron. Of course, you could also just sew the fabric onto your garment!

For this project (image F) I printed an image of a red leaf onto Jacquard silk and sewed it onto one of my white tops. The red in the print matched a pair of slacks I had of the same red color and gave my wardrobe a little extra flair.

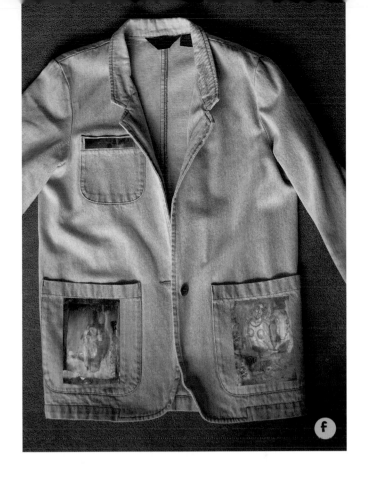

I like to paint on inkjet silk with Jacquard's Green Label Silk Colors. These paints do not make the silk stiff, and they have a great selection of colors.

French Vignettes: A Fabric Collage

by Katherine Drew Dilworth

This was a collaboration that came about after I took a workshop from Theresa Airey on digital printing techniques. After years of working in clothing and surface design, I had recently begun some collage pieces that combined the patterns and textures of fabrics with photographic images. Theresa supplied me with a number of her color photographs printed on Jacquard's inkjet silk and cotton, then gave me free rein in creating the piece.

So often when I have traveled in a beautiful part of the world, I've caught momentary glimpses—a glance from a car or a view from a rooftop—that look like perfectly composed paintings or photographs. When I looked at Theresa's photographs, what struck me was how beautifully they froze these passing moments. It was like looking through a window and seeing what Theresa saw. All of the photographs she gave me to use in this piece were taken in Provence, France and seemed to me to capture perfect vignettes of the place. So, in laying out the collage, I framed the images as if each were a view through a different window.

I used materials from my accumulated collection of fabrics and papers, including vintage clothing and cloth, and pieces that I have batiked or hand-dyed. Some parts of the borders are elements of Theresa's photographs printed on fabric. When separated from the rest of the image, they assumed the look of pattern rather than picture. With the addition of these other collage elements, the images became linked, as well as framed, much like the squares of a quilt.

Once I had pieced the collage together using acrylic matte medium, I added stitching, both for construction and accent, with colored embroidery thread. Many of the stitches are borrowed from traditional Victorian "crazy quilting" techniques. The final step was to mount the piece to a background fabric, using acrylic matte medium as an adhesive and stitching along the top edge. The piece was then ready for hanging and framing.

Katherine Drew Dilworth has worked in surface design since 1992 creating art-to-wear clothing that is sold in stores and galleries throughout the United States. Samples of her clothing have been included in publications on the art and technique of batik. Her most recent clothing line uses screen prints of her photography. She lives in Maryland with her husband and two young sons.

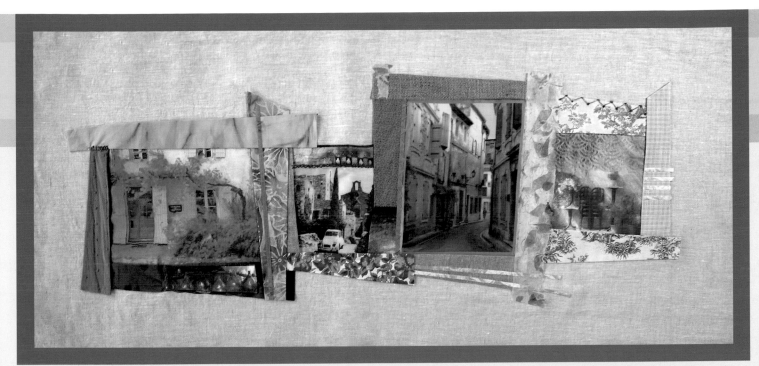

French Vignettes, a fabric collage by Katherine Drew Dilworth.

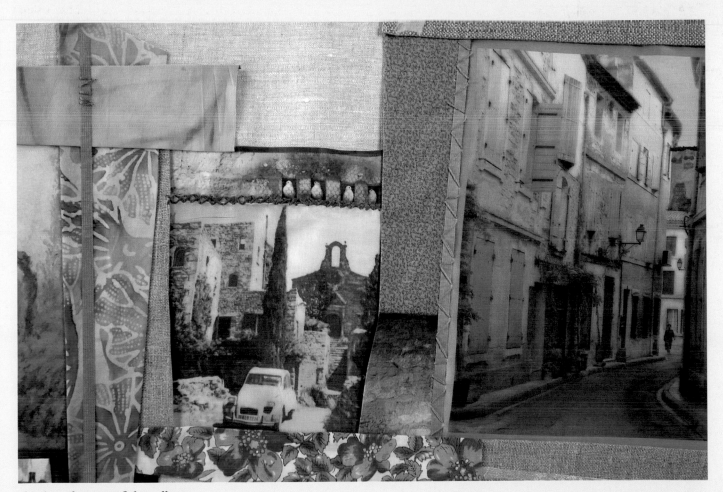

This is a close-up of the collage.

Photo Collages

Photo collages are a great gift idea for holidays, birthdays, graduation, or just about anything. I once made one for a relative who was turning 85. I scanned pictures of her life, from a young woman up to the present day, and used her wedding picture as the central image of the collage. It was such a hit that she had miniatures made up and sent out with the "thank you" cards.

Sam's Graduation Collage

The example illustrated here was used as a graduation gift for my granddaughter, Samantha. I chose the best and the most loved pictures I had of Sam. I tried to select images that told about who she is—her moods, her personality, her expressions. Then, I set out to put them all together into a collage.

1. The first thing to do is to choose a foundation image from the photos you have gathered for the collage. The foundation image should be the one you find to be the most engaging. (The photos surrounding the foundation image will be smaller, but not any less important.) I selected one of my favorite pictures of Sam that had a solid area where it would be easy to insert writing.

Note: If any of the photos you selected for the collage are not in digital form (i.e., prints or negatives), you will have to scan them into the computer to create digital files. Your scanner software should guide you through this process.

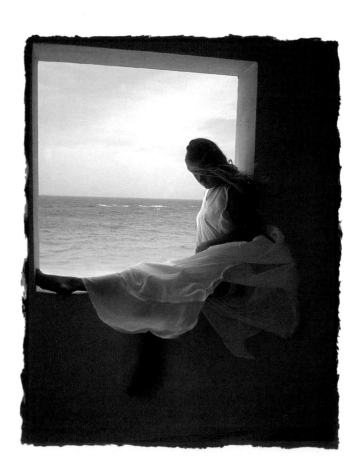

2. Before beginning my collage, I wanted to add a creative edge to my foundation image (left), so I opened the photo in an image-processing program called Auto FX Photo/Graphic Edges. The edge I chose was Volume I, #77. (Auto FX Photo/Graphic Edges can be used as a stand-alone program or as a Photoshop plug-in—see page 84 for more information.)

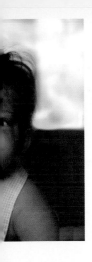
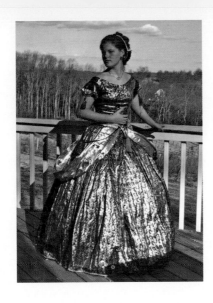

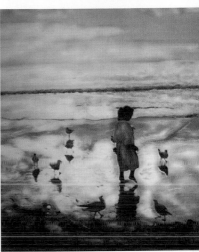

3. The next thing to do is decide what size you want your collage to be. You can make it any size, but you may want to use a common print size such as 8 x 10 or 8 x 12 inches (20.32 x 30.48 cm) so that, if you're giving it as a gift, whoever receives it can easily frame it and find a place for it on a wall or bureau. For this particular project, I used dimensions of 8.5 x 11 inches (21.59 x 27.94 cm).

4. With your foundation image opened in your image processing program, go to File > New. This brings up a palette that allows you to set the canvas size in dimensions of pixels, inches, centimeters, etc. I changed the drop-down menus to display inches, and entered the following information, then clicked OK:

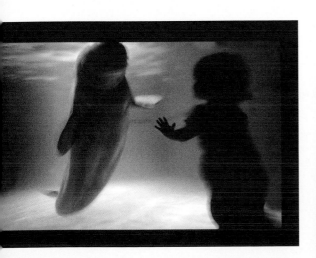

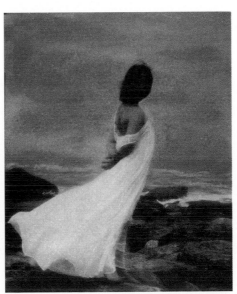

- Width: 8.5 inches (21.59 cm)

- Height: 11 inches (27.94 cm)

- Resolution: 300 ppi

- Color Mode: RGB Color

- Background Contents: White

Note: Now that you have set the canvas resolution to 300 ppi, all the photographs to be dragged onto this new file should also have a resolution of 300 ppi. In Photoshop Elements, open each image separately and go to Image > Image Size to check and adjust the resolution if necessary. If you make any adjustments to the original image, be sure to save the altered image file under a new name!

5. After you've clicked OK, the new file you created to drag your images onto will appear. Now you need to go to View > Rulers to make the ruler measurements appear around your new canvas area.

6. Then, select the Rectangular Marquee tool and section out a measured portion of the blank canvas you created to match the size of your foundation picture. I sized my foundation image down to 4.5 x 6 inches (11.43 x 15.24 cm), so I used the Rectangular Marquee tool to section out 5 x 6.5 inches (12.7 x 16.51 cm) to leave a bit of a white border around the picture. Since I positioned my selection in the center of the canvas area, I was left with approximately 1.75 inches (4.45 cm) on the left and right sides of the selection, and approximately 2 inches (5.08 cm) on the top and bottom.

Note: Your foundation image does not necessarily need to be in the center of the collage. You can compose the images any way you like; just make sure they look balanced in the final layout.

7. Next, I dragged my foundation image over into the center of the canvas area. To do this, select the Move tool from the toolbox, then click on your foundation image with your cursor. Hold the cursor down and drag the image over onto the new canvas, releasing the cursor when it is placed where you wish it.

Note: You can move the image around as long as that particular layer is active. (There will be an eyeball icon next to the active layer in the Layers palette.) If you leave that layer and wish to come back to it, simply go back to the Layers palette and click on the layer containing the image you wish to move. Select the Move tool again and move the image to wherever you need it to be.

8. I then selected how many images I wanted to include around the edges and sized them down to fit in the space allotted. (Refer to step 6 to see what space I was working with for this project, but every project is different and you will need to size-down your additional images to fit the specific space available in your piece.)

9. To make placing my "secondary" images easier, I chose one photo for each corner of the page and placed those first. I chose vertical images for each of these and made them slightly larger than the rest of the images I planned to place. It is just a

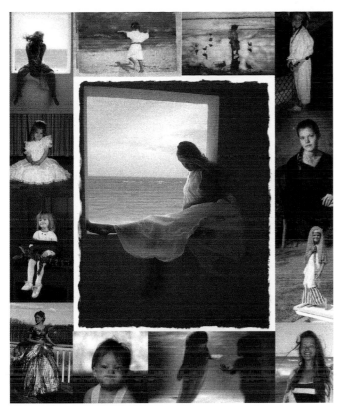

Here is the final collage composition before I added text.

matter of working with the space that you have and cropping the shot so that you like it. I think making some images larger than others is more appealing than having them all one size, but it is entirely up to you to decide what look you want for your piece.

10. Sam's mother, Lisa, wrote a poem for her that I also wanted to include in the collage. (If you are not a writer yourself, you can always quote someone else's words that are meaningful to you.) I wanted to type in the poem where it could be read easily and not interfere with the image. The bright window area seemed like the perfect spot.

11. Select the color that you want the text to be by double clicking on the foreground square in the toolbox. When you do this, the Color Picker palette will appear. You can go into the Color Picker and select a color, or you can take the cursor over to your image and click on a color found in the picture.

12. Once a color has been selected, the next thing to do is choose the font and type size. To do this, simply select the Text tool (designated by the letter T), choose an area where you wish to begin typing, and click on it. When you do this, the associated drop down menus (such as font type and size) will appear at the top of the screen.

13. Type in your text, then highlight it using your mouse. Use the text drop down menus that appeared at the top of the screen when you first activated the Text tool to play with the font and type size until you find one that suits the image. When you are done, you can use the Move tool to adjust the placement of the text if need be.

14. When the font looks how you want it to, go to the Layers palette. You will see that the text is in a separate layer from the background file you created, and that each of the pictures is in its own separate layer. If you wish to move the text or any of the images around, just make sure that the relevant layer is highlighted in the Layers palette and use the Move tool to drag the photo or text wherever you wish it to be.

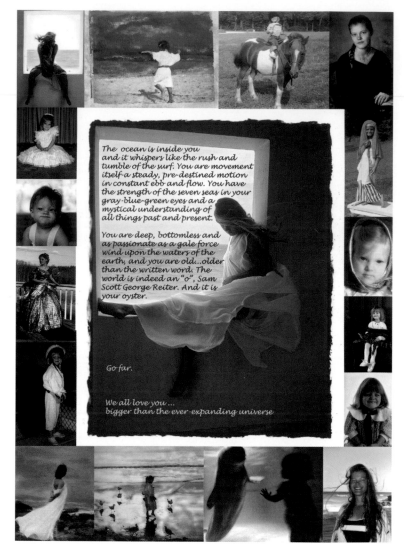

Here is the completed collage, with text.

Note: If you stop typing to move layers around, then go back to the Text tool to continue typing, a new text layer will be created. If you do not wish to have more than one layer of text, make sure to go back to the Layers palette and select the text layer you've already begun before continuing to type. Personally, I like to have different parts of the text in different layers so that I can move sections of it to create a more interesting composition without moving the whole text. In this particular collage, I made the last bit of text a separate layer and changed it to a turquoise color that I found in the ocean part of my foundation image. To me, the turquoise color really tied the piece together.

17. For something like this collage, I will save the image two ways. First, I save it with all the separate layers intact. Then, I save it as a flattened, single layer image. Even though the layered one is a larger file, it helps to have it if you need to go back and change a word or insert a different image. You just select that layer and make your change. You cannot access the different layers once the image has been flattened into a single layer; you would have to start all over to make a change. When saving two different collage versions, I usually designate the layered file with the letter L, and the flattened file with the letter F (i.e., SamGradCollage_L.tif and SamGradCollage_F.tif).

More Collage Ideas

Create a themed collage surrounding you or your loved ones' favorite activities—playing sports, biking, fishing, theater, spending time with friends, etc.

Do you know someone who is retiring from his or her job? Place their picture in the center of a collage and surround it with photos of them at award's dinners, holiday parties, in the office, coworkers, company trips, etc.

How about a collage for a pet lover! You might choose a picture of them with their animals as your foundation photo, then surround it with images of each animal, and times spent with them, past and present.

My son and my grandchildren participated in a program called Dolphin Quest and I was there as the "official" photographer. It was a memorable experience, and they had so much fun that I wanted to find a way to display several images of that day, not just one or two. So, I arranged the pictures that I liked into a digital photo collage. I made the final print 9 x 12 inches (22.86 x 30.48 cm) for easy framing, then I kept one and sent one to my son. The kids liked them so much that I made each of them a copy and they took it to school for "show and tell."

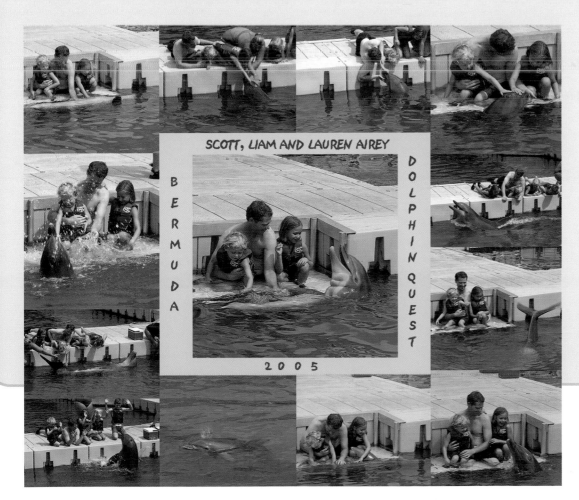

SCOTT, LIAM AND LAUREN AIREY

BERMUDA

DOLPHIN QUEST

2005

Chapter Four: Creating Sketch-Like Renderings and Blended Images

Turning your color or black-and-white images into sketches is another simple and fun way to get creative with your photography. You can use these sketch renderings as cards, frame them as pencil sketches, add interest to your scrapbooks, or use them as a sketch base from which to do a painting. When selecting an image to create a sketch rendering from, be aware that the more detailed the image is, the better the sketch rendering you will obtain. Architectural images with significant structural designs work great, for example.

I really liked this photo of my granddaughter Samatha and wanted to see how it looked as a sketch rendering.

When working with images of people for sketches, profiles or side views work best. Full frontal shots, no matter how great a portrait it is, will often end up making the subject look like monster. That said, I am often pleasantly surprised when turning an image into a sketch, so if you have an image you really like and you're wondering how it would look as a sketch rendering, the best thing to do is to just try it. It only takes a minute, and if it doesn't work, so be it. Nothing ventured, nothing gained.

As with most full-frontal people shots, this photograph did not translate well into sketch form. This is not a flattering rendition of this beautiful young lady.

Six Easy Steps
from Photo to Sketch

Select an image you wish to transform into a sketch and open it in your image-processing program. To make a black-and-white sketch of a color print, you must first change the color image to black and white.

1. Start by duplicating your image and saving the duplicate under a new file name. In Photoshop Elements, go to File > Duplicate. In Photoshop CS, go to Image > Duplicate. To give the duplicate file a new name in either program, go to File > Save As.

2. Now, in Photoshop Elements or Photoshop CS, go to Image > Mode > Grayscale. A dialog box will pop and ask you if you want to discard the color information. Click OK, and the image will immediately change from a color image to black and white.

3. If your black-and-white image looks a bit flat, in Photoshop Elements, go to Enhance > Auto Levels and see if that gives your image more "snap." In Photoshop CS, go to Image > Adjustments > Auto Levels.

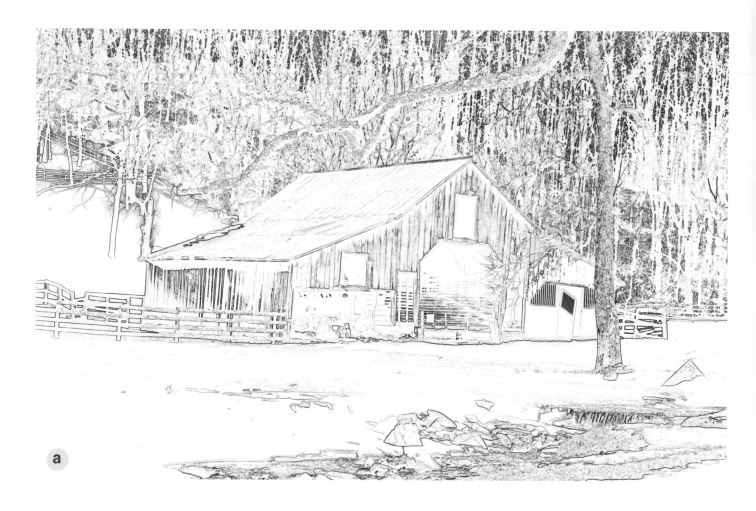

a

4. Next, go to Filter > Stylize > Find Edges. Your image will immediately convert into a black-and-white sketch (image A, above). However, it is still in Grayscale mode. In order to add color, or if you plan to layer your sketch with a color image, you must convert the file back into RGB mode.

5. Go to Image > Mode > RGB Color. The file will remain as a black-and-white sketch, but it will be an RGB Color file. Now you can tone the sketch with color, or overlay it with a color image and blend it in Layers.

6. To accent the drawing or sketch, you can put a black border around the image (image B, above). To do this, first make sure that the Background square in your toolbox is black. (If it's not, click on it and

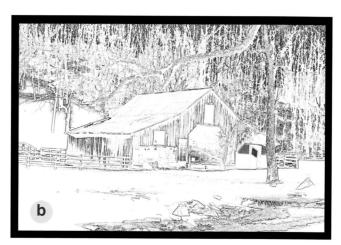

b

change it to black when the Color Picker dialog box appears.) Then, refer to the sidebar on the following page for instructions on how to create a border.

Image Borders

Placing a border around an image sets it off and creates an internal "frame" within the image file. When working with a black-and-white image, a black border usually looks best. When working with a color image, you may want to sample a color from within the image so that the border compliments the image nicely.

1. Go to the toolbox and click on the Background square. The cursor will become an eyedropper and the Color Picker dialog box will appear.

2. Next, go into the image and click on a color. Whatever color you click on, the background square in the Color Picker dialog box will become that color. (You may also use the Color Picker to select a color.) When you have selected one that you like, click OK. The Background square in the toolbox should now be the color you selected.

Hint: Darker colored borders usually look best.

3. Now you need to add some space around the image for your border. In Photoshop Elements, go to Image > Resize > Canvas Size. In Photoshop CS, go to Image > Canvas Size. Change the dimensions to add whatever amount of border space you wish to the image area. If your image is 8 x 10 inches (20.32 x 25.4 cm), for example, and you wish to put a half-inch (1.27 cm) border around it, change the canvas size to be 8.5 x 10.5 inches (21.59 x 26.67 cm) and click OK. Your image will appear with a half-inch border of the color you selected.

4. If you do not like the color of the border once you see it around the image, simply go to Edit > Undo Canvas Size (or use the keyboard shortcut Command/Cntrl+Z), then return to step 1 and start over.

Blended Images

In this section, we will take one color image and create a black-and-white file, a brown-toned file, and a sketch file of the same shot. Then, we will blend selected files in the Layers palette to create unique and exciting images. These creatively styled photography pieces are great as large prints suitable for framing, or as small prints to be used on cards for friends and family.

Black-and-White Sketch Blends with Color Photos

a

1. To start, I made a duplicate file of the original color photograph of Samantha reading by the ocean (image A). In Photoshop Elements, go to File > Duplicate. In Photoshop CS, go to Image > Duplicate.

2. Next, click on the duplicated image to make sure that is the active image, then go to Image > Mode > Grayscale.

3. Now, in Photoshop Elements, go to Enhance > Auto Levels, or in Photoshop CS, go to Image > Adjustments > Auto Levels. This will brighten your black-and-white image and give it more contrast (image B).

Hint: For the purposes of this example, we will be dragging the black-and white sketch rendering over onto the original color image and blending them. However, you can also try doing the opposite; drag the color file on top of the sketch file.

This will not affect the look of the image (it will remain black and white), but the file needs to be in RGB Color mode in order to blend the sketch with the original color image.

Note: If you leave the sketch in Grayscale mode and try to blend it with the original photo, it will change the color image to black and white.

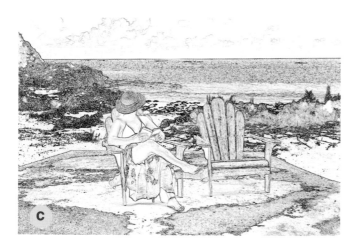

4. Then go to Filter > Stylize > Find Edges, and the image will immediately become a black-and-white sketch (image C).

5. Once you have turned the image into a sketch, change the file mode to RGB Color instead of Grayscale by going to Image > Mode > RGB Color.

6. Now select the Move tool from the toolbox, hold down the Shift key on your keyboard, and click on the sketch rendering and drag it over onto the color file. Keeping the Shift key held down while you do this will ensure that the two images register

precisely. You will see both layers in the Layers palette, the black-and-white sketch on top of the color image (image D).

7. In the Layers palette, click on the drop-down menu that shows the word Normal. This is where you can access the blending modes. Scroll down to try out the various options. For this project, I used the Luminosity blending mode (image E).

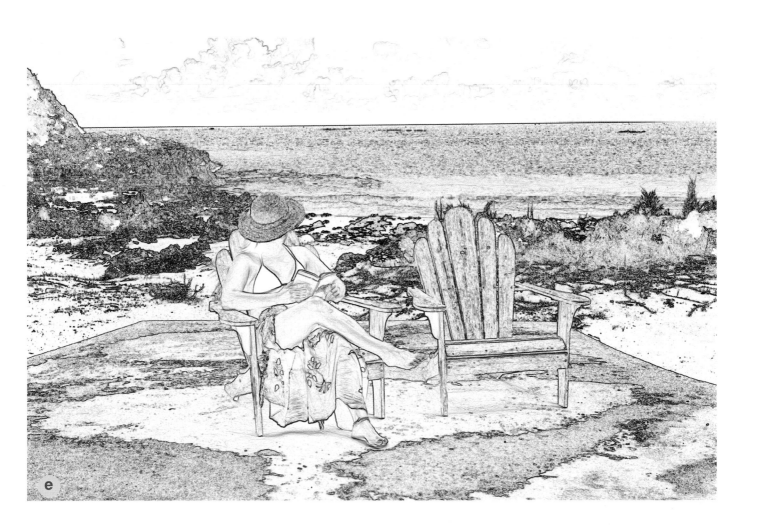

Color-Toned Sketch Blends

For this project, you can start with a black-and-white image if you want to. Starting with a color image is fine, as well, but we will be converting it to black and white.

1. Take your original photo and duplicate it in Photoshop Elements by going to File > Duplicate, or in Photoshop CS by going to Image > Duplicate.

2. Next you'll need to turn both the original and duplicate images to black-and-white (if they're not already) by clicking on each, one at a time, and going to Image > Mode > Grayscale.

3. Now, for each of the two images, in Photoshop Elements, go to Enhance > Auto Levels, or in Photoshop CS, go to Image > Adjustments > Auto Levels. This will brighten them up and add some contrast.

4. Then, for both images, select Image > Mode > RGB Color to change the color mode.

Note: If you leave your files in Grayscale mode, you will not be able to add color tone, so you must be sure to change both files back to RGB Color mode after you have transformed them into black-and-white images.

5. With the first image only, in Photoshop Elements, go to Enhance > Adjust Color > Color Variations and select Increase Red then Decrease Blue from the dialog box that appears. In Photoshop CS, go to Image > Adjustments > Color Balance and adjust the Cyan/Red slider towards

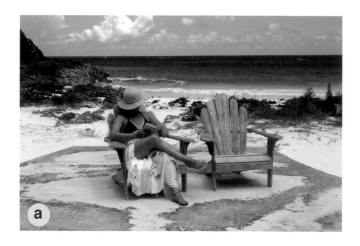

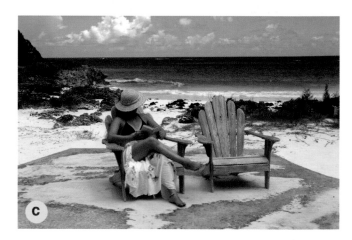

Red by +40. Then adjust the Yellow/Blue slider towards Yellow by -40. This will result in a nice rich brown tone.

6. If your brown-toned image comes out looking too orange (image A), in Photoshop Elements, go to Enhance > Adjust Color > Adjust Hue/Saturation and move the Saturation slider (image B) to the left until you have removed the orange color cast (image C). In Photoshop CS, go to Image > Adjustments > Hue/Saturation and do the same.

7. Now go back to the second image, which is still just black and white, and go to Filter > Stylize > Find Edges to turn the image into a black-and-white sketch.

8. Then take your newly created sketch and drag it over on top of the brown-toned shot. Or, as I did for this piece, drag the brown-toned image over onto the sketch. Whichever you choose to place on top, remember to hold the Shift key down when you do this so that the images line up perfectly.

9. The last thing to do is go to the Layers palette and play with the blending modes to see which one looks best to you. To do this, just click on the drop-down menu in the Layers palette that displays the word Normal. I chose the Luminosity blending mode.

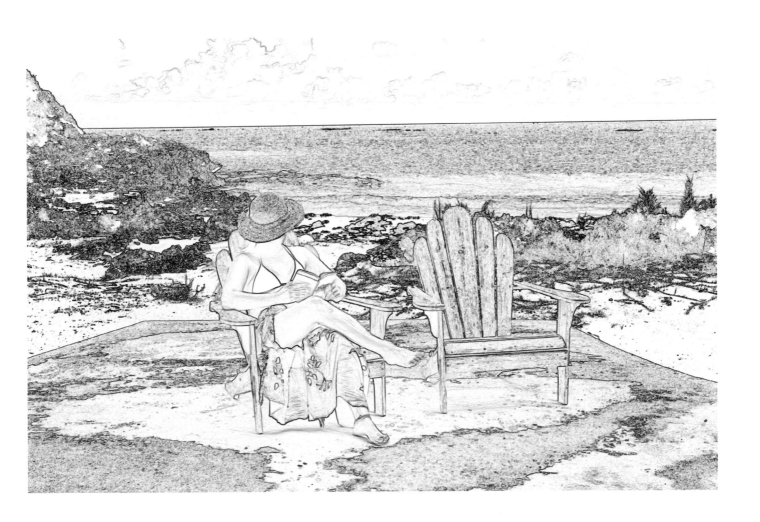

Experiment and Have Fun!

There are so many incredible effects that can be achieved by combining sketch renderings with your images, and equally as many image variations you can make of those images to combine the sketches with! Here are a few more possibilities for you to ponder.

Here, I tried dragging the color image sketch blend from page 81 over onto the brown-toned photograph from page 82, then blended those two images together using the Hue blending mode in the Layers palette. This produced a great brown-toned image with a slight hint of color.

The Auto FX Photo/Graphic Edges software has around 10,000 different edges that you can apply to your images. Fog, vignetting, painterly effects, and print making edges are just a few examples of what they have to offer. The edge shown here is volume 3, #18 with a slight "burn" to the edges.

For this version of the image, I just took the brown-toned photo and made a sketch rendering from it, then applied the volume 3, #18 edge from Auto FX Photo/Graphic Edges. I printed it out onto Arches' cold pressed watercolor paper, painted on it with watercolor paints, and used it as a Mother's Day card for my daughter.

Here is the brown-toned sketch printed out onto watercolor paper and colored with watercolor pencils. I colored them on dry, then used a wet cotton swab to create a "wash" of color over the sketch.

Chapter Five: Book Making

Books are capable of making a far deeper impression on a viewer than a single image or group of photos can. They create a continuous story line through words or images, or both. And besides that, they are just plain fun to make!

There are many ways to make books. This chapter addresses one way in particular, but as you will see, it lends itself well to many permutations. The book-making technique depicted here was taught to me by Arlinka Blair, an extremely creative artist who resides in Hawaii for most of the year. She has a deep connection with the island and the Hawaiian people, and the work she produces clearly illustrates this (see page 99).

Themes, Images, and Colors

What kind of book do you want to make? The theme of your handmade book can be anything you want it to be, from a favorite vacation or memory to a visual representation of your current mood! Once you've decided on a theme, collect a series of images to go along with it. These images can be your own photographs, or scraps ripped from a magazine, or both. The book that I will be using as the main example in this chapter was created around the central theme of old-world Italy, using images from Sicily and Naples that I had taken on one of my trips. I call it my Sicily book.

When you have gathered together a set of images you'd like to use, choose a nice background color that will either contrast and enhance or blend in with your imagery. In the case of my Sicily book, I chose a dark gray acrylic paint streaked with light gray for one side of my base sheets, and on the other side I did the opposite, painting first with the light gray color then streaking over it with the dark gray. After folding the pages and cutting them, I had a spread of two predominantly dark gray pages followed a spread of two pages with the lighter gray background. (Refer to pages 88-97 for step-by-step book making instructions.)

Choosing a Base Material

Now that you have some idea what kind of book you'd like to make, it's time to choose a material for the book base. Choose one of the following:

- Rosin paper: This is a roll of pinkish paper that you can purchase at a hardware store. It is traditionally used to cover up floor surfaces during construction and it is very inexpensive. This paper easily absorbs paints and gel mediums and ends up feeling like leather instead of paper.

- Watercolor paper: I would suggest a paper between 140 – 300 lbs., as you will be collaging on the surface and it will need to be strong and durable.

- Printmaking paper: Here again, be sure to choose a heavy, durable paper.

- Handmade artist papers: Handmade papers tend to be more fragile than watercolor papers, as they do not contain sizing. I would not recommend doing your first book with these papers. Instead, do a book with heavier papers first so that you will be familiar with the process.

Other Materials

- **Acrylic matte medium:** For use as a glue, acrylic matte medium can either be diluted with water or used straight.

- **Gel medium:** Gel medium is a bit thicker and stronger than acrylic matte medium, and is useful for attaching thicker papers or heavier items. I use it straight from the jar.

- **Exotic papers:** Attaching unique or exotic papers can add dimension to your images.

- **Scissors:** Plain scissors will work fine, or you can use craft scissors, which have difference edges and can be purchased at any craft store.

- **Paint:** Acrylics and gouache paints work well and dry quickly. You may also want to purchase some iridescent paints or powders to layer on.

- **Shellac:** Amber or clear shellac will work best for this project.

- **Hole puncher:** Any hole puncher will do. You can find one at any craft store, as well as at many drugstores and grocery stores.

- **Binding thread:** I usually use strips of leather or some sort of twine for binding.

- **Gloves:** Surgical gloves or dish-washing gloves work fine.

Caution: Some mediums contain things that you do not want building up in your body over time. Use sticks or brushes to apply them, and if you wish to use your fingers to spread them around, be sure to wear gloves.

Forming the Book

You can make your book any size that you wish. I used a piece of paper that was 24 x 36 inches (60.96 x 91.44 cm) for the Sicily book, which gave me folds (pages) that were 9 x 12 inches (22.86 x 30.48 cm). In other words, each page ended up being 9 inches (22.86 cm) wide and 12 inches (30.48 cm) tall. The smaller the original paper you use, the smaller the individual pages will be.

Preparing the
Paper and Making the Folds

Follow these steps closely and the preparation process will be very easy. All you need to do is coat the paper with primer, paint in your background colors, then fold and cut the paper into book pages. Once you have accomplished folding your first book, the rest will be simple!

1. The first thing to do with the paper you have selected is coat it with primer (image A). You can buy any brand of white primer paint at your local hardware store. After it is dry, turn it over and paint the other side.

2. Once the coat of primer is dry, select whatever background color or colors you wish to use and paint each side of the paper accordingly, waiting for one side to dry before painting the other side (image B). (Refer to page 87 for advice on how to select background colors.)

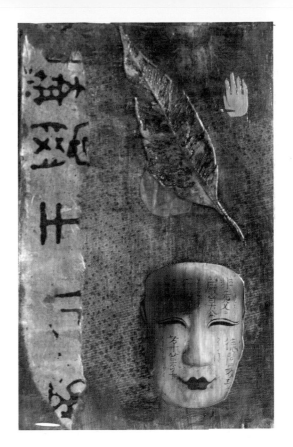

Hint: To add an interesting texture to your painted paper surface, while the paint is still wet, blot some of it away gently with a paper towel. The pattern from the paper towel will be left in the paint surface, as seen in the photo above.

3. Once you have finished painting your base paper, spread it out vertically in front of you (i.e., one of the two shorter edges should be closest to you—image C).

4. Next, fold the paper in half, bringing the top of the paper down towards you (image D).

4. Now fold it in half again, bringing the left side over on top of the right side (image E).

6. Unfold the paper and you will have eight equally sized panels. Now you need to grab some scissors and cut a slit in the center of the squares (along the vertical line that runs between squares 3–4 and 5–6 in the diagram shown in image G).

Hint: I numbered each of the sections in the folding diagrams to help illustrate the folding steps. If you find it useful, you could use sticky notes to number your panels and follow along as you work.

5. Then fold the paper again from top to bottom (image F).

7. Once you have cut a slit in the center of the panels, with both hands, lift the panels and fold the top half back behind the bottom half. (Panels 1, 2, 3, and 4 should be behind panels 5, 6, 7, and 8—image H.)

8. Now fold the number 6 panel towards you, down over the number 8 panel. This will expose the number 4 panel (image I).

9. Take the newly visible number 4 panel and fold it behind the number 7 panel (image J).

10. Then take the number 5 panel and fold it behind the number 7 panel (image K).

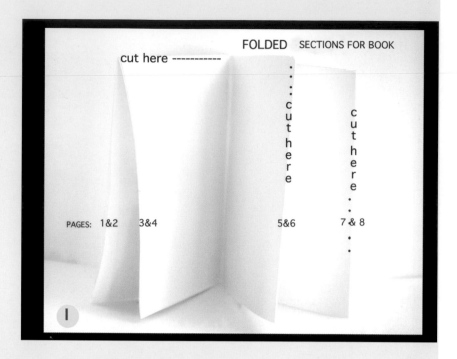

FOLDED SECTIONS FOR BOOK

cut here -----------

c u t h e r e

c u t h e r e

PAGES: 1&2 3&4 5&6 7&8

I

11. Now all you have left to do is make three cuts. You have three folds that need to be cut to make eight separate pages. The first fold you need to cut connects pages 1, 2, 3, and 4. Cut this panel at the top to create four separate pages. The next two folds run lengthwise between pages 5–6 and 7–8. Cut these to free the remaining book page panels. (See image L for a visual representation of where you need to cut.)

Now you have created eight separate pages. You may elect to glue them together in twos to give you four heavier, sturdier pages, or you may want to use all eight. When I glue pages together, I use gel medium, as it is thicker and heavier than the matte medium. When I know that I will be collaging heavier elements into the book (such as leaves, twine, or heavier paper from books and magazines), I usually opt for this gluing method so that I have thicker pages to work with.

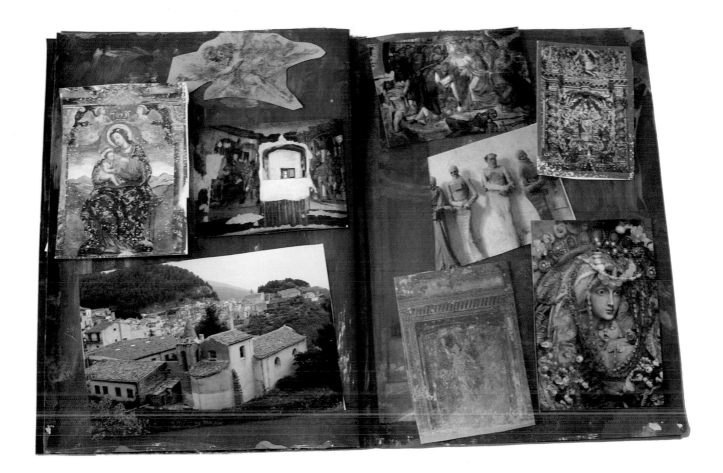

Filling In the Pages

Now that you have the base of your book ready to go, its time to gather up your images and start laying out each page. I like to make a practice layout before I glue anything down. Start with a key image or two and work around that, selecting other images to compliment the feeling or statement you believe the main image is making.

In the case of this page spread from my Sicily book (above), I began with a few images that I liked and then selected additional images with the similar content or feeling and moved them around until I felt the page was balanced in imagery as well as color.

If possible, it is good to lay the entire book out on "story boards." I cut mat or cardboard the same size as the book and do the two-page layouts on these. Set them aside somewhere safe once you've created a basic layout, then come back to them later with fresh eyes to evaluate them and make changes if you wish. Sometimes I completely change things around. Other times I keep a few images in place and add new images or other collage elements; you can use ticket stubs, stamps, bits of cloth, words, "found" imagery (magazine or brochure shots), etc., and interweave these items into the layout. These extra bits and pieces will help unify the images and bring your page together.

Of course, setting your "practice layout" aside and reviewing it later is the ideal situation. If you have animals or small children that may disturb your tentative layout, it would probably be best to start gluing the images down as soon as you are satisfied with them. When you are ready to finalize your page layouts, begin with the first set of pages (two pages that face each other in the book) and glue the images down with either acrylic matte medium or gel medium. (The gel medium works better for attaching heavier materials.)

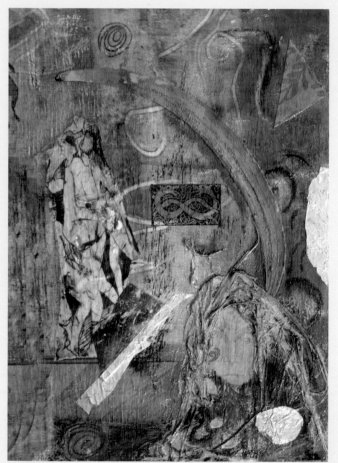

In this page from an Asian-themed book I made, I used only found images and I interwove them with leaves, string, stamp art, hemp, a Koa leaf, and bits of foil.

With the Sicily book, I did not wish all the prints to have the same look or the same finish, so I decided to transfer some of the images onto exotic papers before using them. (Refer back to pages 47-51 for details on the image transfer process.) This gave the images a unique, almost antique look.

When the images are glued in place and dry, I begin to integrate them with acrylic paints and collage fabric and/or other materials that I think will enhance or emphasize the feel of the page.

As you begin to glue images together, your pages will take on a life of their own, and you will intuitively know if something works or if it doesn't. Balance each page as you work; be open, trust your sense of composition, and go with the flow. After all the pages have been painted and/or collaged, I give them a coat of Golden's semi gloss gel. Do this one spread at a time and let everything dry thoroughly. This can take a day or two depending on the humidity in the air. The gel coating gives the book pages the feel of leather. After all the pages have been coated and are dry, I trim the edges of the pages evenly with a ruler and box cutter. You can also creativity cut the edges with a design or with pinking shears (scissors with a zigzag edge).

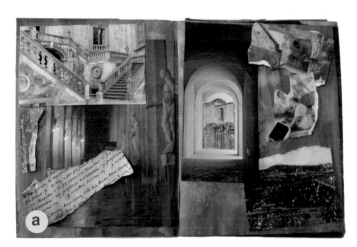

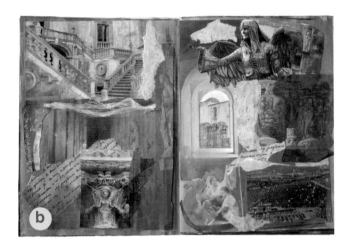

Here you can see the original layout for one of the page spreads in my Sicily book (image A), as well as that same spread after I collaged and painted on it (image B).

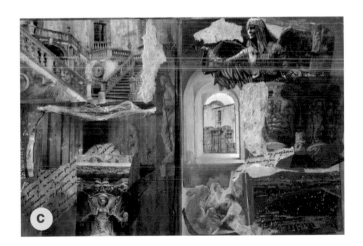

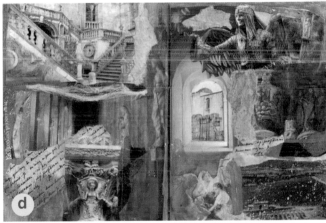

Notice the change in the color of this page spread from the original (image C) to the spread after amber shellac has been applied (image D).

To add an antique or vintage look to your pages, you can give the final book a coat of amber-colored shellac. Just coat one spread at a time and wait for each section to thoroughly dry. Do this on a nice dry day to facilitate the drying process. The amber shellac will change the existing colors in the images, giving them a translucent golden hue over-

all. If you do not wish to change the colors or the finish, you can use clear shellac or another type of varnish. You can also just paint the amber shellac on selectively in certain areas.

Here is the finished cover of the Sicily book (image A), but I felt it was too somber looking. So, I added some red and yellow paint, then varnished it with amber shellac, which gave it a nice warm golden color (image B). This created the feeling that I was trying to achieve.

Binding the Book

When you have finished filling in the pages of your book and all the paint, glue, and varnish have dried completely, open it up to the center and mark out where you wish the binding to be.

You can see here that I used a ruler to create evenly spaced marks along the binding where I wanted the holes to be.

Then, take a hole puncher and punch out binding holes along the spine of the book, following the marks you made as to where the binding should go. Be sure to do this on a hard surface so that you get a clean hole and don't tear the paper. After I had the holes punched in the spine, I used multi-colored leather that matched the page colors to bind the book.

Cord, twine, braided string, or just about anything you wish can be used to bind the book together. You could also sew the book together by hand or on a sewing machine with string or a heavy cord. When the book is bound, you can then add coins or charms to finish the binding off. I chose a coin at the end of the leather binding to finish off the Sicily book.

I used colored leather to bind my Sicily book.

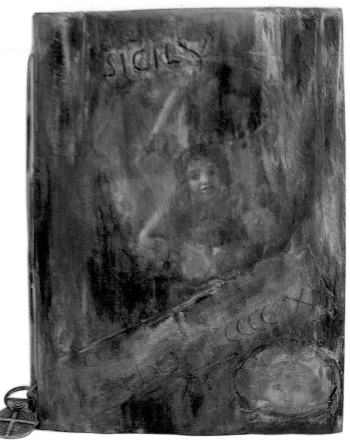

Here is the final cover of the Sicily book. You can see the leather binding and the attached coin.

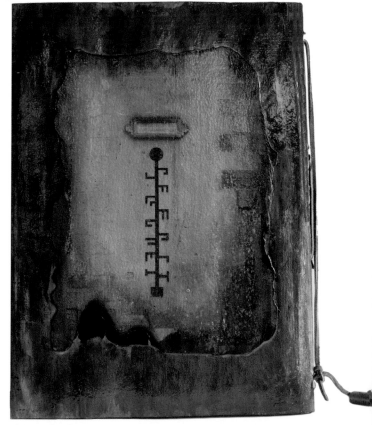

This is the back cover of the Sicily book.

Hawaii: A Handmade Book by Arlinka Blair

As I mentioned at the beginning of the chapter, Arlinka Blair is the artist who taught this book-making technique to me. Her books are created using found objects, stamps, and various other imagery that she draws or finds in magazines or on an old postcard, etc. This piece, entitled Hawaii, illustrates how diverse this approach to book making can be, and how many elements can be incorporated into the process.

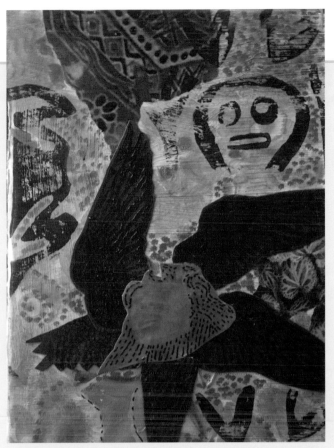

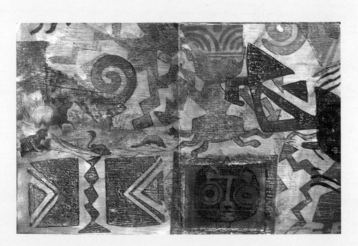

This is the cover of her book.

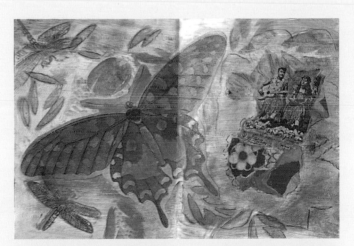

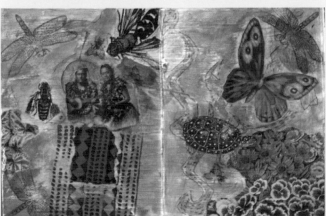

Before and After

Here are several pages from the Sicily book illustrating their original layout as compared to the final page. The final pages have been coated with the amber shellac. Hopefully, this will give you a good idea of how far your imagery can go with additional painting, collaging, and varnishing.

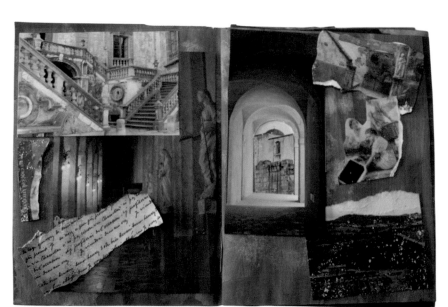

Before

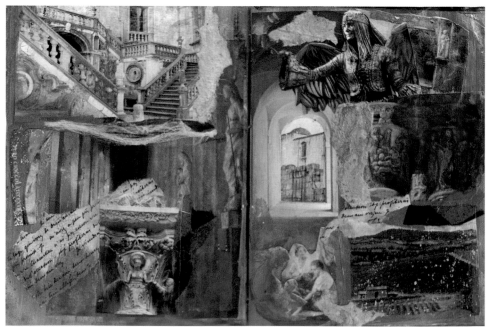

After

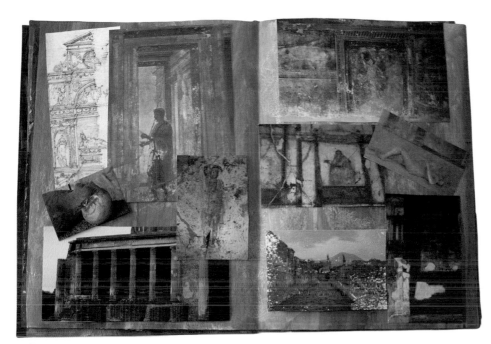

Before

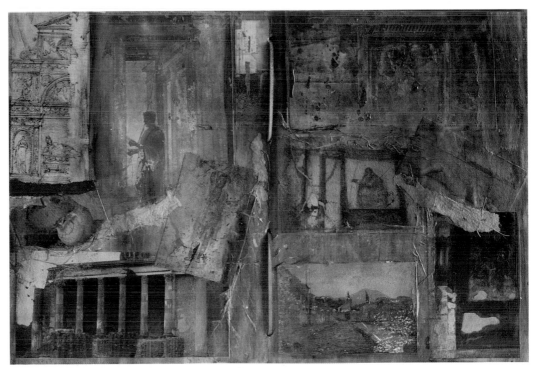

After

Taking the Pages Beyond the Book

After I finished the Sicily book, I began to take pho-
tographs of the page layouts with my digital camera.
I readily saw that these page-layouts would make
beautiful prints. So, I opened the photographs of the
various page layouts in Photoshop and did a bit of
"cleaning up," such as using the Clone/Stamp tool to
clone out the visible spine area. The layouts turned
out to be wonderful art prints with a dimensionality
that could not be attained by digitally collaging with
Photoshop Layers alone. The texture of the paints
and collaged papers gave a depth to the now two-
dimensional image that could not have been
achieved any other way.

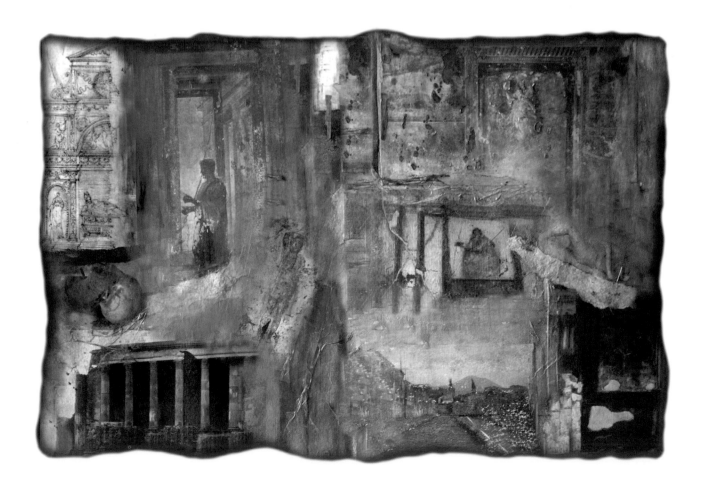

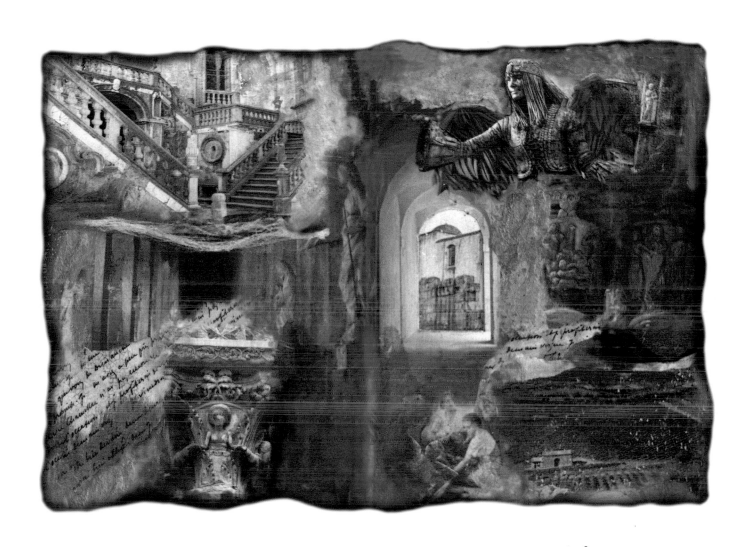

glossary

acid free papers

Papers that have a pH of at least 6.5. They do not have any acidic materials in them.

assemblage

The layering or gluing together of found objects. Assemblages typically have a more three-dimensional quality than collages. Pieces created using this medium are usually referred to as "mixed media." *See also* **collage.**

baren

A Japanese tool for rubbing or applying even pressure. Traditionally, they were made from bamboo; today they are made from fiberglass. They are used for making hand transfers (as opposed to using a printing press).

blotter paper

A heavy, absorbent paper used to dry prints or to help spread out the moisture in dampened papers before printing.

cold pressed paper (CP)

A textured paper with a slightly toothy surface. It will accept pastel coloring and watercolor pencils very well, and is made by running the paper through textured cold rollers. *See also* **tooth.**

collage

The layering of materials (such as papers, fabric, or photographs) on top of an image. Also, the layering of materials to create an image. Pieces created using this medium are usually referred to as "mixed media."

complementary colors

Colors that are opposite each other on the color wheel.

earth colors

Refers to ochres, siennas, and umbers—the most stable of natural pigments. *See also* **pigment.**

gesso

A painting ground traditionally made from rabbit skin glue and white pigment (titanium or zinc) or Plaster of Paris. It is used to coat the surface of canvas, linen, cotton, paper, or other fabrics in order to prevent the acids in oil paint from deteriorating the substrate on which an oil painting is made. *See also* **ground; substrate.**

glue size

One of the substances used as a ground. It is applied to porous substrates in order to prevent over-absorption of the intended mediums. *See also* **ground; substrate.**

ground

A barrier painted onto the surface upon which an oil painting will be made. The barrier prevents the acids in oil paints from deteriorating the fibers of the receptor substrate. *See also* **substrate.**

hot pressed paper (HP)

A smooth surfaced paper that will yield more details in your image. It is made by running the paper through hot rollers.

hue

A particular shade of color. Paint that has the word "hue" in the color name (i.e., Naples Yellow Hue) indicates that a substitution has been made to mimic a pigment that is poisonous in its natural form.

intensity

The degree of brilliance in a color.

light fastness

Refers to the degree of permanence a pigment has with regard to fading from light.

monochromatic

Composed of a single color or various shades of a single color.

printmaking paper

These papers have little or no sizing so that they can absorb inks more quickly. *See also* sizing.

rough paper (R)

A highly textured paper that has a bumpy, irregular surface. You will lose details when transferring images to paper of this type. It is made by running the paper through heavily textured cold rollers.

shade

A color mixed with black.

sizing

A substance (i.e., glue or gelatin) that is used to reduce the absorbency of paper or canvas.

substrate

In the art world, an underlying layer upon which mediums are applied (i.e., paper, wood, metal, etc.).

tint

A color mixed with white.

tone

Refers to the lightness or darkness of a color. Also called value.

tooth

The roughness of a paper or other substrate surface.

watermark

The paper manufacturer's logo.

wet strength

The strength of the paper when it is wetted.

index

J

Jacquard **62**, **67**

L

layer mask **14**, **24**
Layers **12**, **14-15**
Lazertran **57**

M

memory boxes **56-62**

N

negatives **41**

O

organza **64-66**

P

paint **88**
photo collages **70-75**
practice prints **43-46**

R

rename **43**
resizing images **44**

S

scanning images **41**, **70**
scrapbooking, digital **10-29**
silk **63**
sizing **36**
sketch blends **79-85**
sketch-like renderings **76-78**

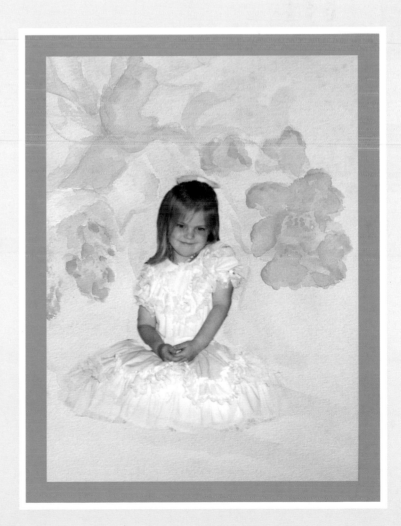